SEA GLASS
RARE AND WONDERFUL

C.S. LAMBERT • PHOTOGRAPHS BY TINA LAM

Down East Books

Camden, Maine

Guilford, Connecticut

Down East Books

An imprint of Globe Pequot

Distributed by NATIONAL BOOK NETWORK

Copyright © 2017 by C. S. Lambert (text) and Tina Lam (photographs)

British Library Cataloguing in Publication Information Available

Library of Congress Cataloging-in-Publication Data Available

ISBN 978-1-60893-653-3

ISBN 978-1-60893-654-0 (e-book)

∞™ The paper used in this publication meets the minimum requirements of American National Standard for Information Sciences—Permanence of Paper for Printed Library Materials, ANSI/NISO Z39.48-1992.

Printed in the United States of America

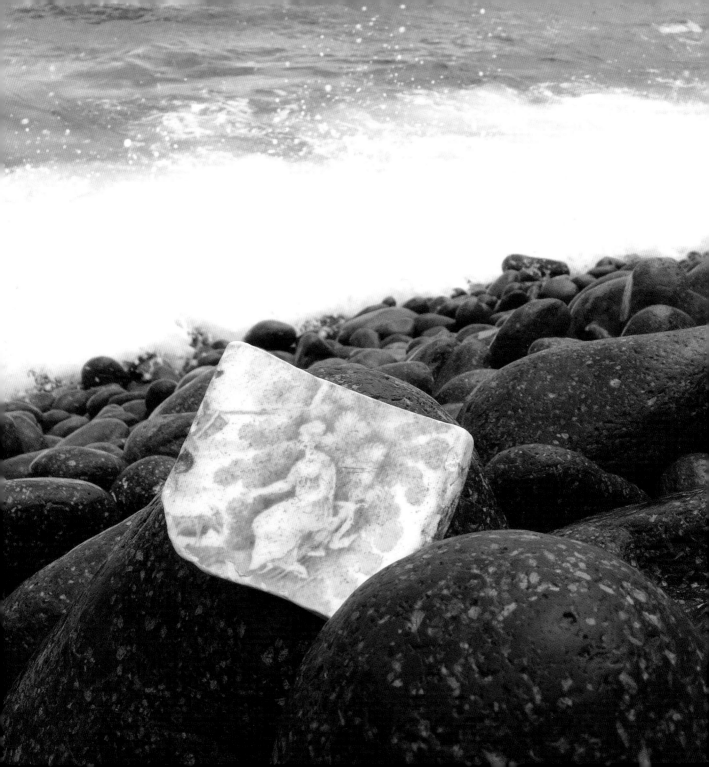

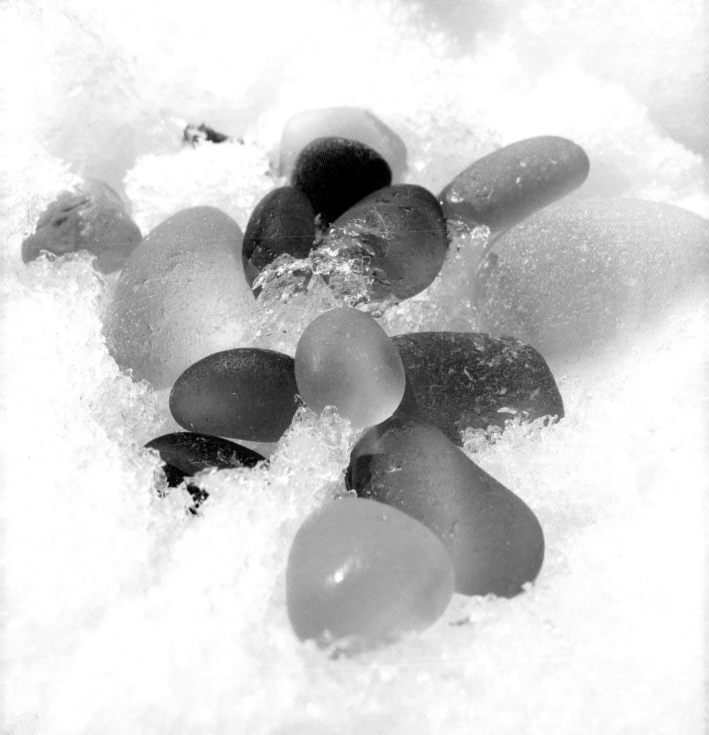

CONTENTS

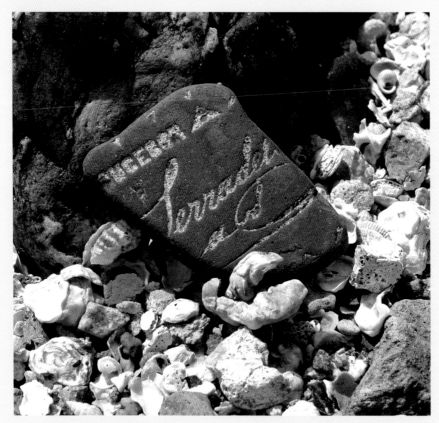
This 3" x 2" pottery shard was found in Gran Canaria, Spain.

To my family and friends, who have stood by me, no matter what.

—C. S. Lambert

To my parents, John Lam and Isabella Chin, whose artistic talents, courage, and passion for life live on in me and my children. I draw infinite energy from happy childhood memories of family picnics at the beach, with mom painting, dad composing poetry, and classical music in the background—all immortalized by my dad's photography.

—Tina Lam

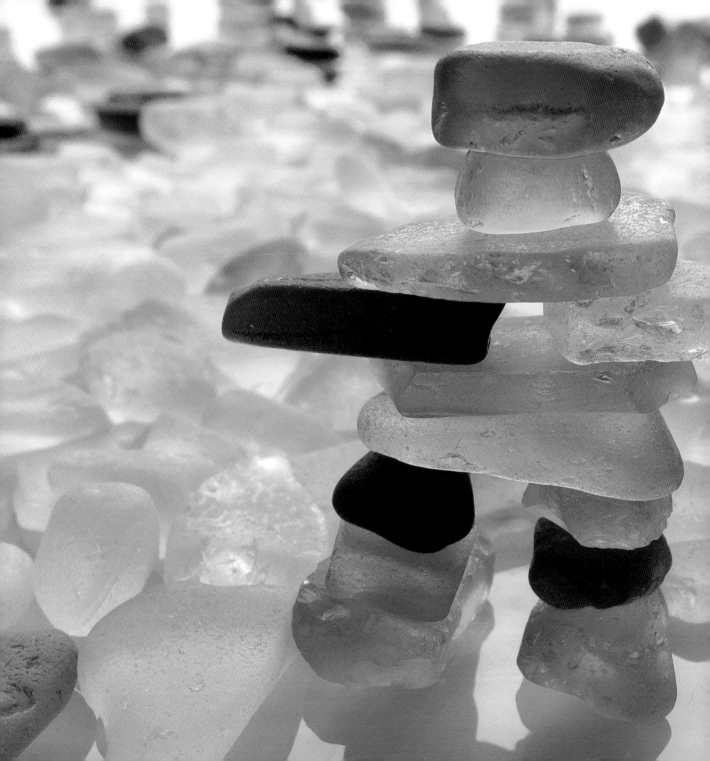

FOREWORD

The ocean never rests. Waves, currents, and wind act as couriers, casting debris to the beach and then reclaiming it. The pattern repeats and history is presented in the unlikely forms of broken glass and pottery. Somehow, these fragments of utilitarian and decorative goods are fragile enough to break, yet strong enough to survive years of tumbling in the surf. During this chaotic voyage, the ocean sculpts the imperfect, jagged edges and adds its own signature of subtly pocked surfaces.

Four times a day the sea pauses, then reverses direction. For a moment, the world seems to pause and catch its breath.

> Sea glass can be considered from different angles—triggering memories and opening up ways to interpret both past and future.

Considering the oceans' 140 million square miles, sea glass is infinitesimally small, yet these shards reveal what we have in common with the rest of the world. Sea glassers who examine colors, shapes, and designs are ocean-side archaeologists. They might place shards in historical context—what they were and what was going on at the time the original object was created. With sea glass, the ocean often blurs the differences between history and fiction, past and present—the fragment of a candy container found in Maine represents a car designed for World War II combat in Europe; an antique French pottery shard found in Pennsylvania recalls Marie-Antoinette's favorite makeup; a red shard found in Puerto Rico evokes a 10th century Persian glass with magical powers.

Artists and artisans could not possibly have imagined that fragments of their work would connect decades of strangers, or that the process of decay might fascinate beachcombers in the future. One thing sea glassers have in common is that they find and preserve these rare and wonderful shards from the past before they slip away and disappear forever.

Author's Note: All the pieces in this book are shards—fragments of whole glass and pottery. All have been found by ocean, river, and lake beachcombers, and in a few cases, divers.

This bottle stopper resembles a sea urchin or small glass pumpkin cast upon the shore. It was found on the southern coast of Hong Kong and measures 1⅜" in diameter.

These curious colored rings are actually the broken-off tops of bottle necks.

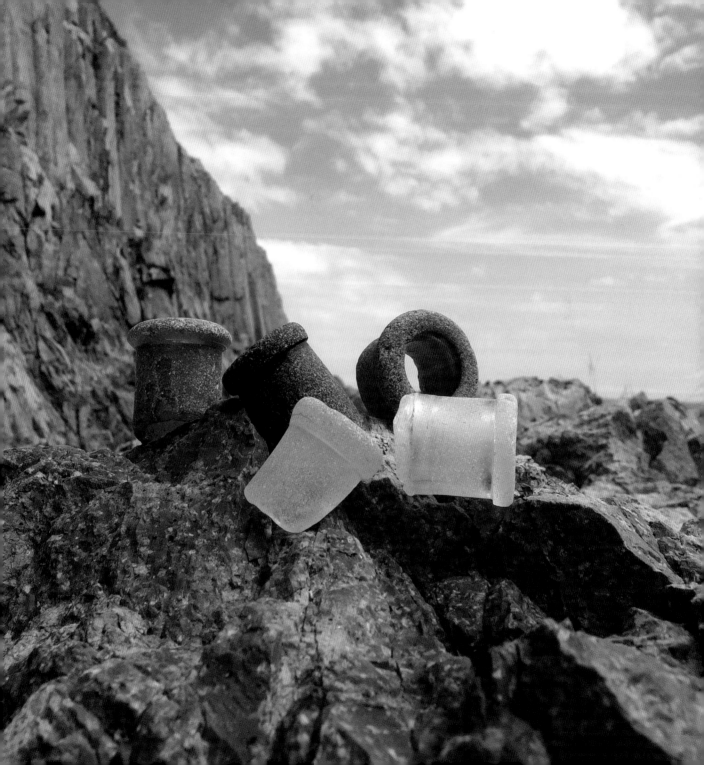

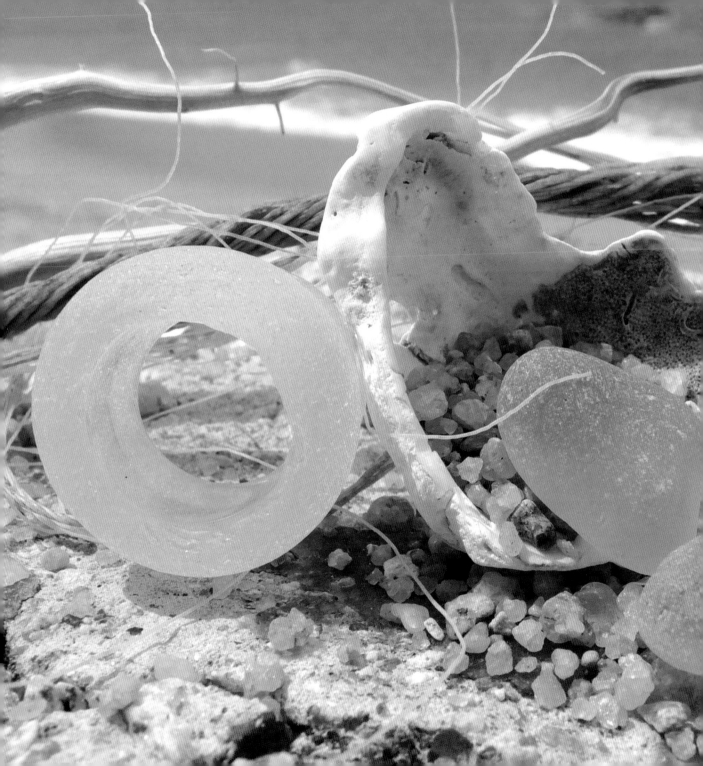

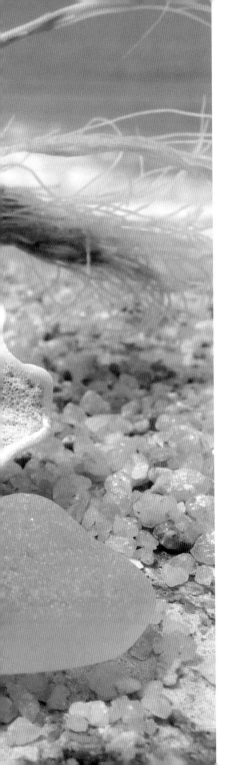

THESE FRAGMENTS INVITE
BEACHCOMBERS TO
SIFT THROUGH TIME
AND ENTER OTHER UNIVERSES.

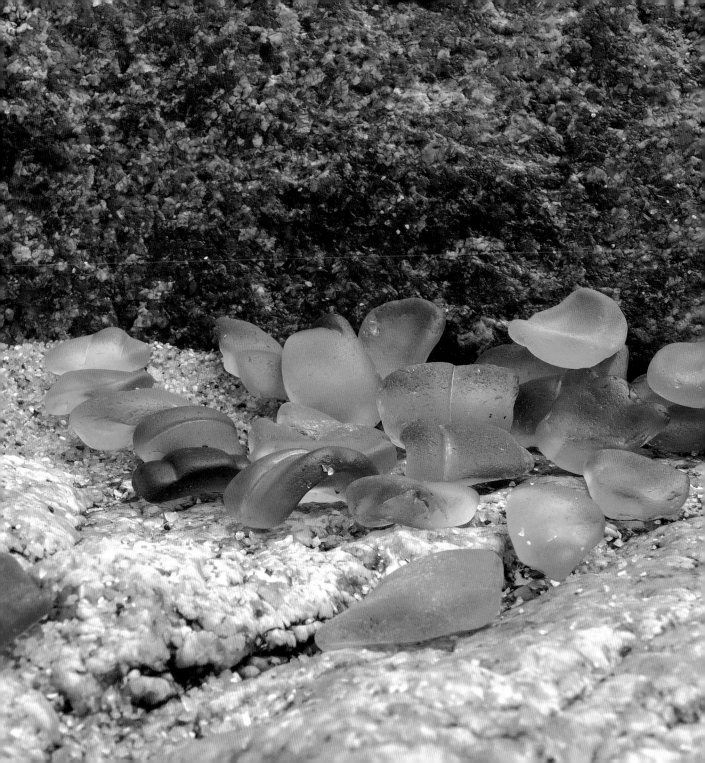

Jewels in the Sand

Sea glass and gemstones have a lot in common. Both can be appraised according to color and hardness, but often by opposite specifications. Diamonds rank among the most favored gems—clear, radiant, and rare. Ironically, the sea glass equivalent, white glass, falls on the other side of the spectrum because it is usually lackluster and common. Gems are also valued according to their purity, yet with sea glass, pocking and other flaws add to its desirability. Of course, as with any comparison, there are all sorts of variables. For example, sapphires, normally thought of as blue, actually occur in a rainbow of colors. Padparadscha sapphires, known for their beautiful salmon color are the most sought after. *The Carter Sea Glass Color and Rarity Guide* by Meg Carter, has become an industry standard. In the Carter guide, the colors daffodil, sunflower, and cranberry rank among the highest and most sought after. Other sea glass evaluations also determine rarity, such as the overall volume in specific colors, glass quality, the glass's altered state, and location. Ultimately with sea glass, it's all about its distinctive, flawed beauty.

In 2011, Elizabeth Taylor's Burmese ruby and diamond ring sold for $1.5 million at Christie's. While no one can doubt the ring's value, few could afford these gemstones. But you can't put a price on the unsolved mysteries encapsulated in sea glass.

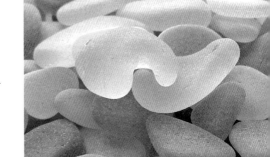

Neither flower petals nor chips of jade, these teal shards, rare in the United States, were gathered in Gran Canaria, Spain.

Dracula's Beer of Choice

Deep in Romania's Carpathian Mountains, citizens of the small town of Azuga are said to keep to themselves. When *Dracula* was published in 1879 there were whispers about the connection between Bram Stoker's gothic horror and the Azuga Beer factory. According to legend, Stoker's book had been based on the true story of Count Dracula—a vampire, an un-human—who lived in a castle perched high on a scraggy cliff near the brewery. The locals had been heard to say that he slept between dawn and sunset, confined to his wooden casket deep below his castle, and that he never went out in the daylight. Azuga Beer employees still mention ancestors who reported a gray vapor entering the factory through a broken window, and the night-shift workers who wore long hair or scarves to hide small puncture marks.

This fragment from an Azuga beer bottle, found in Athens, Greece, measures approximately 2¼" x 1½".

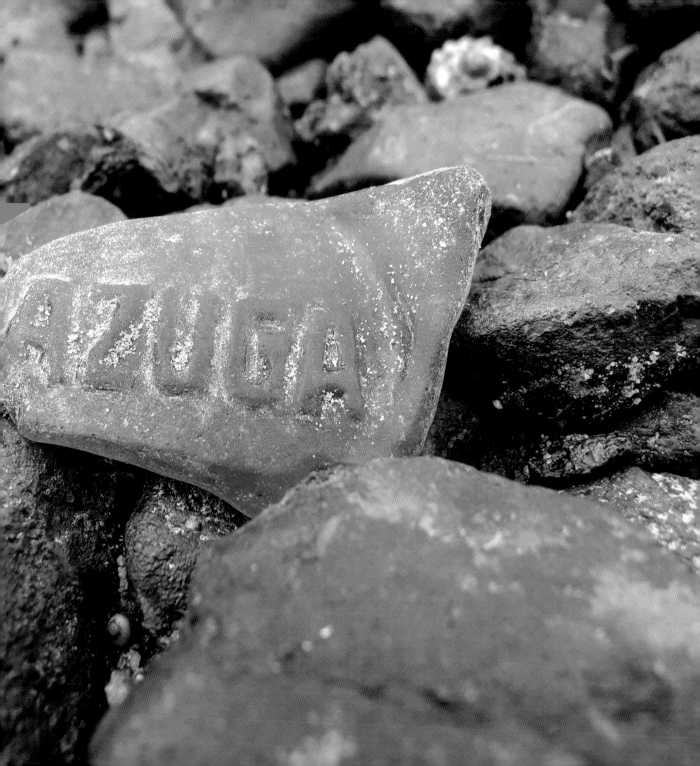

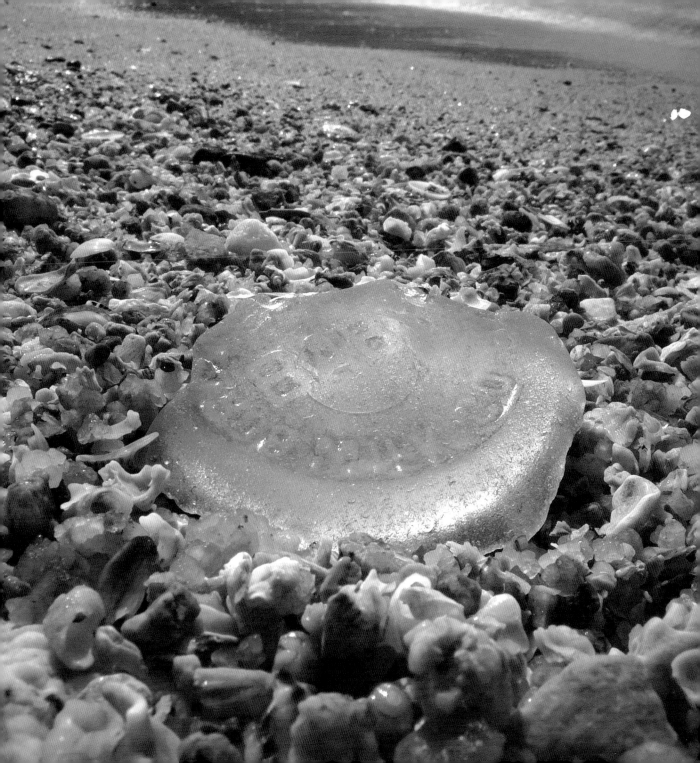

Better Babies

In 1911, the first life-size cow created from five-hundred pounds of butter debuted at the Iowa State Fair. Since then, butter sculptures, along with Ferris wheels, tractor pulls, and agriculture and livestock exhibitions have become a late summer rite of passage throughout the nation. Also in 1911 at the same venue, the American Medical Association and the Iowa Congress of Mothers co-sponsored the first "Better Baby" competition. Infants aged six to thirty-six months were judged on their height, weight, symmetry, size of ears, and disposition—criteria similar to the competition for the largest pumpkin and most unusual macaroni sculpture.

It may never be known if Borden, once America's largest producer of dairy and pasta products, contributed to the five-hundred pound butter sculpture in Iowa. But according to an advertisement in a 1915 issue of the *Literary Digest*, "If your baby does not measure up to the standard of the Better Babies movement, the first and most important thing to be considered is the question of feeding. It is not mere chance that so many prize winners in Baby Shows have been raised on Gail Borden Eagle Brand Condensed Milk."

This piece from the bottom of a Borden milk bottle dates to the early 20th century. It measures 2" in diameter and was found in Owls Head, Maine.

Cult of Mourning

During six decades as British monarch, Queen Victoria influenced politics, fashion, and social conduct in England and much of the world. Overwhelmed by the death of her husband, Prince Albert, in 1861, Victoria wore mourning attire and lived in seclusion for the remaining forty years of her life. She initiated what became known as "the cult of mourning," and directed that members of her court must dress in black for the three years following Prince Albert's death.

Victoria's court and England's elite preferred jewelry made from jet, a rare fossilized coal found primarily in Whitby, England. Yet this delicate and expensive mineral was in such demand that Whitby's cliffs were in danger of collapse, and mining was declared illegal. Most of the population who had wanted to follow Victoria's fashion trend did not have the means to buy jet even before mining was outlawed, so black glass was the alternative used by the masses.

This Victorian shard depicts a child at play. Found in Kirkcaldy, Scotland, it measures 2½" x 2¼".

A 1½"-diameter mourning button, circa late 19th century, found in Kent, England.

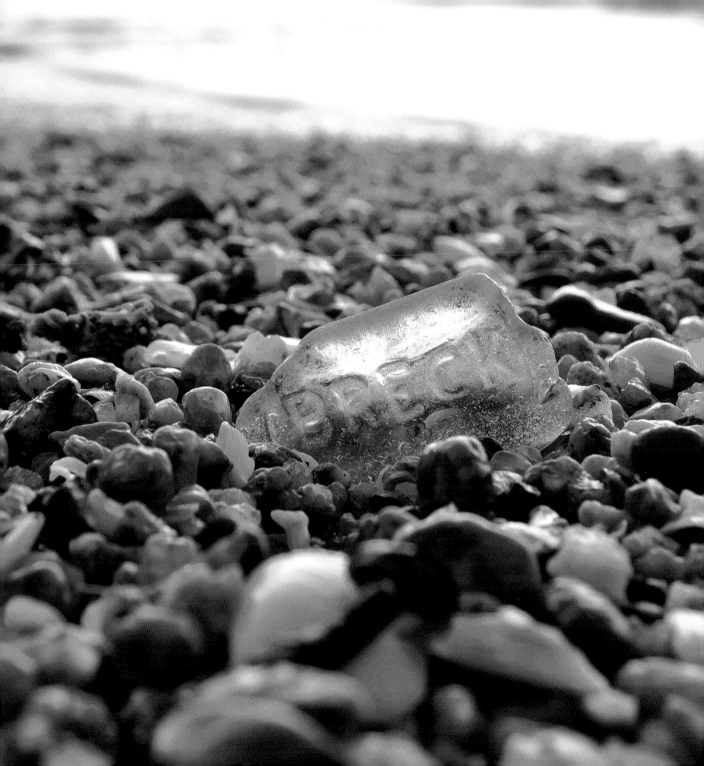

Wholesome Beauty

Following a series of risqué films and well-publicized scandals involving Hollywood stars in the 1920s, the Motion Picture Producers and Distributors Association created censorship guidelines that banned, among others things, on-screen profanity and nudity. The guidelines also stated that kisses could last no longer than three seconds and that violators must be punished. The period from 1930 to 1950 became known as Hollywood's Golden Age, when women wore softer hairstyles, less harsh makeup, and more modest clothing than in previous decades. Leading ladies such as Doris Day, Ginger Rogers, and Debbie Reynolds portrayed women with wholesome good looks. The advertising agency for the Breck shampoo company capitalized on the idealized version of American women and employed non-professionals, mostly blondes, to promote their shampoo. The original publicity images were painted in pastel colors with a halo-like effect. This helped create one of the most recognizable advertising symbols—the iconic Breck Girl—that continued through the 1960s.

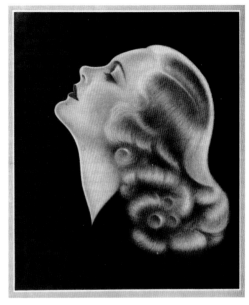

1948 ad for Breck shampoo from Ladies' Home Journal.

Found in Fort Bragg, California, this shampoo bottle bottom, circa 1950s, measures 1¾" x 1".

Keeping the Fizz in Fizzy Drinks

Nearly a century and a half ago, British mechanical-engineer-turned-soda-magnate, Hiram Codd invented a peculiar bottle that revolutionized fizzy drinks. The outward appearance of the Codd bottle's slumped, slightly twisted neck resembles Salvador Dali's melting watches.

This was achieved by inserting a marble into the bottle's neck, and pinching it while the bottle was still in the molten state—creating a chamber to trap the marble. By filling the bottle upside down, the pressure from the gas forced the marble against a rubber gasket at the top of the neck, and sealed in the carbonation. Advancements in bottle technology have replaced the Codd bottle, and they are scarce today, not only because they are considered obsolete, but because in the late 19th and early 20th centuries, children often broke the bottles to retrieve the marbles. In some parts of the world, Codd bottles have been used to create improvised cannons by filling them with calcium hydroxide.

Example of a Codd bottle (© Raimond Spekking/CC BY-SA 4.0)

This 3" x 1½" bottle neck and marble was found on England's Kent dump beach.

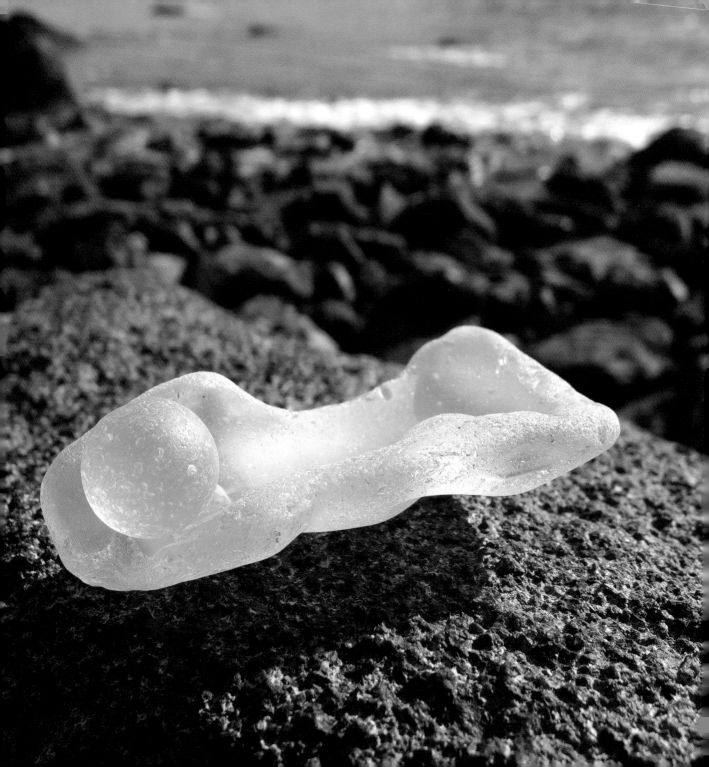

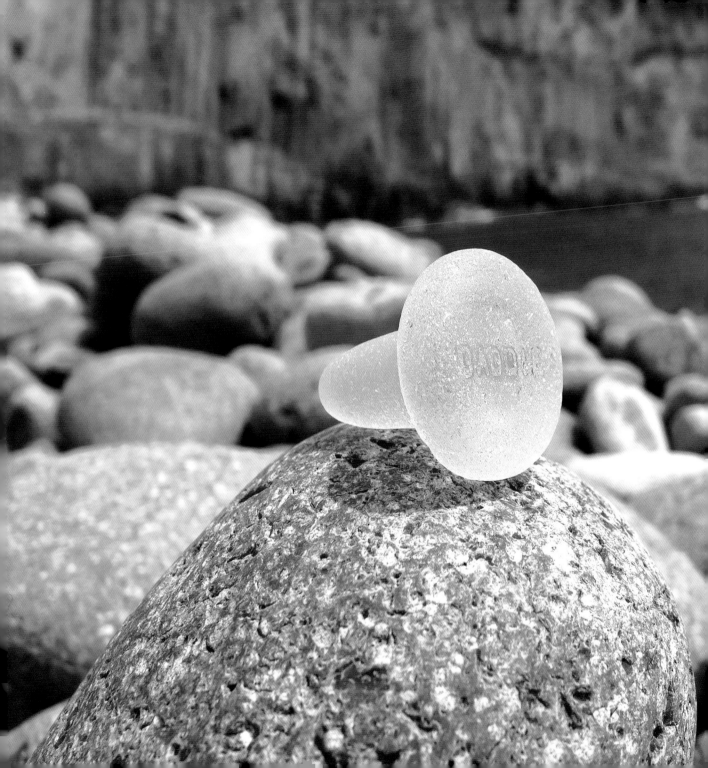

Brown Sauce

The English call it "brown sauce," a thick viscous mixture of malt vinegar, tomatoes, fruit, spices, and other ingredients, depending on who's making it. Brown sauce goes well with toad-in-the-hole, bacon sandwiches, and even coffee, apparently, as demonstrated by Colin Farrell in the film, *Intermission.*

Some food historians attribute England's favorite condiment to an entourage of chefs brought from Spain in the 16th century by Queen Katherine of Aragon—King Henry VIII's first wife. Another milestone for England's premiere condiment: Prime Minister Harold Wilson used such copious amounts on his food that brown sauce became known as "Wilson's Gravy."

This stopper, faintly embossed with "Daddies," came from a brown sauce bottle, circa early 1900s. Found in Broadstairs, England, it measures 1¼" tall by 1" diameter across the top.

Davenport Glass

Like the prospectors who rushed west in search of gold, sea-glass treasure hunters vie for a different kind of nugget—Lundberg glass from Davenport, California. This highly sought-after sea glass originated in the Lundberg Studio, a fine-art manufacturer of limited edition paperweights, vases, and bottles. During a rainstorm in the 1970s, an overflowing creek sent containers filled with discarded glass trimmings out to the ocean. Arguably the finest in the world, Lundberg shards are known by their intricate patterns and shapes.

Surfers and divers familiar with Davenport Beach usually wear wet suits while trying to stay upright against the monster waves that pound the rocky shore. Grabbing up treasure with custom-rigged scoops, nets, and shovels, they probably work harder than any other sea glassers in search of treasure that is constantly on the move. More pedestrian hunters work along a briefly exposed beach where sneaker waves still can gash and bruise, and even break bones. At least one sea glasser has lost his life there. The Hawaiian proverb, *Mai Huli oe I Kokua o Ke Kai*—"never turn your back on the ocean"—is well known in California.

The range of colors and patterns found on Lundberg glass is truly astounding. An assortment of seventy-five pieces collected from Davenport Beach sold on eBay for $1,800.

Lundberg glass can be found in only one place, Davenport, California. This piece is 1¼" tall.

Doll's Eye

In the operating room at the Hospital de Bonecas, founded in Lisbon, Portugal, in 1830, doctors in white coats rely on old-world techniques as much as modern surgical instruments. Unlike most hospitals, de Bonecas admits only dolls and the occasional teddy bear. In this former 18th-century schoolhouse, racks and drawers hold countless eyes, arms, legs, torsos, and heads—mostly spare parts from dolls that are beyond repair—to fix everything from priceless antiques to toys of purely sentimental value.

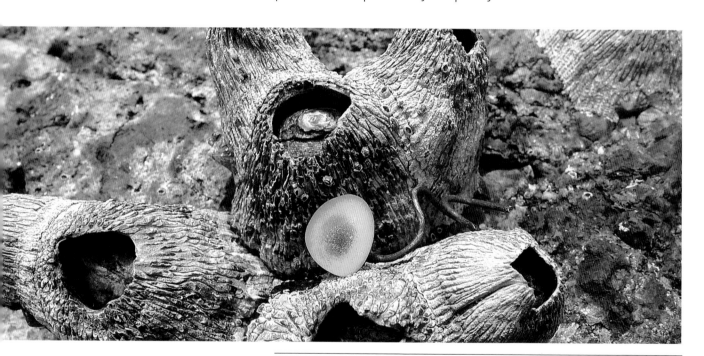

Found in Rockland, Maine, this glass doll's eye measures ¼" in diameter.

Made from recycled sake bottles, most Japanese floats come in various shades of green.

Fish Nets

Of the five major oceanic gyres—huge spirals of seawater formed by colliding currents—the North Pacific Gyre spans most of the ocean between Japan and California. Glass fishing-net floats, hollow spheres that support large commercial fishing nets, have been in use for more than a century and a half. If separated from the net, a float might be caught in the North Pacific Gyre indefinitely, or some diversion in weather patterns might push it east until it makes landfall on America's northwest coast. Usually hand-blown from recycled glass, older floats might contain bubbles and specks of carbon, brick, and other impurities.

Jeep

In 1941, Willys-Overland Motor Company created a lightweight, rugged vehicle that could withstand the hardships of war. Named Willys MB, the car soon became known as the "Jeep," possibly after the *Popeye* comic strip character Eugene the Jeep, an animal with supernatural powers.

World War II–era toys and games, often with military themes, promoted morale-boosting entertainment. Make-believe heroes, such as Captain America, Wonder Woman, and Superman marketed patriotism and good triumphing over evil. One of the most highly recognizable images at the time, the Jeep, was made in a series of glass curios by the J.H. Millstein Company in Jeannette, Pennsylvania.

This candy container, with "Willy's Jeep" embossed on the sides, was found in South Thomaston, Maine. It measures 4¼" x 1¾".

Maraschino Mystery

This is the horrifying, unadulterated tale of the maraschino cherry. First of all, it isn't a cherry, *per se*. In 1940, the Food and Drug Administration identified maraschino cherries as "cherries which have been dyed red, impregnated with sugar, and packed in a sugar syrup flavored with oil of bitter almonds or a similar flavor." Sort of like "Velveeta" isn't really cheese, but a "cheese food product." In truth, maraschino is a clear liquor made from distilled marasca cherries found almost exclusively on the Croatian coast. There, in the early 1800s, Italian housewife Maria Luxardo experimented with a medieval recipe called "rosolio maraschino." Her husband saw the potential in his wife's cottage industry and opened the Luxardo Distillery in 1821.

Eventually the Austrian emperor authorized the distillery to emboss the Austro-Hungarian coat of arms on bottles as a symbol of the emperor's patronage. The distillery was later destroyed in World War II, and the only surviving family member, Giorgio Luxardo, fled the country with one marasca cherry seedling and re-established the family business in Italy.

Dating to the early 20th century, this embossed seal with the Austro-Hungarian coat of arms came from a Luxardo bottle. It was found in Newport, Rhode Island, and measures 1¾" in diameter.

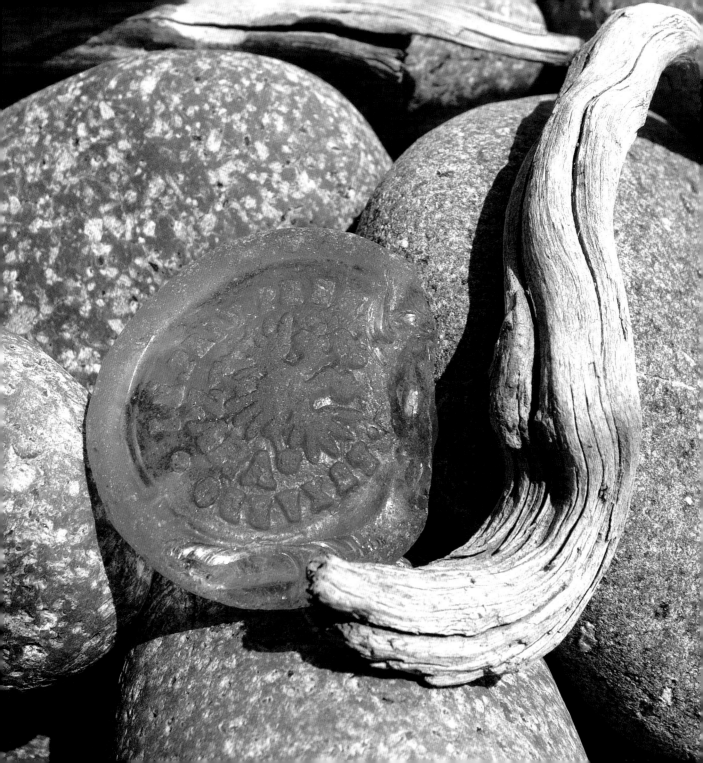

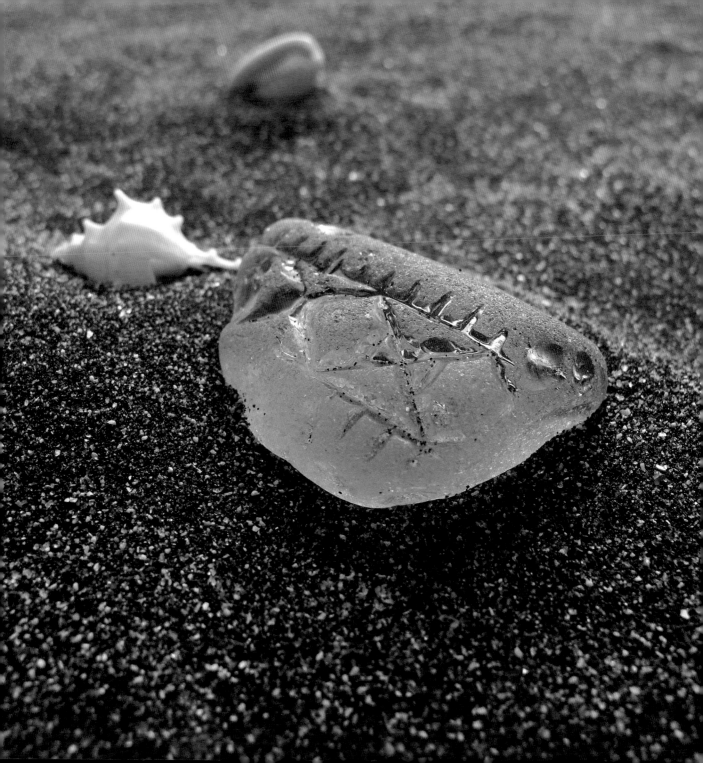

A new kind of fashion jewelry? This sea glass ring is actually a perfectly rounded piece of a broken bottle neck. Found in Greece, it measures 1" x 1".

This fragment, circa 1930s, originated from a clear, pressed glass bowl. Manganese, a critical ingredient in the manufacture of clear glass, was used to remove the green tint that occurs from iron impurities inherent in the glass. But when exposed to ultraviolet rays, the manganese caused the glass to turn purple. This piece was found in Camden, Maine.

Pickled Mr. Pickwick

In his first novel, *The Pickwick Papers*, Charles Dickens created the character of Samuel Pickwick, a retired businessman, who enlisted three friends in search of the " . . . quaint and curious phenomena of life." They consequently fell into a series of mishaps, aided by fair amounts of alcohol.

Dickens was admired by Fyodor Dostoyevsky, author of *Crime and Punishment*, and Dostoyevsky's wife Anna recorded in her diary that Fyodor introduced her to Dickens's writing as part of her "literary education." During a ten-year imprisonment and exile for dispersing revolutionary ideas, Dostoyevsky read little, but notably he took a copy of *The Pickwick Papers* with him.

Because of his drunken escapades, the character of Mr. Pickwick has become an advertising icon for alcoholic beverages.

This likeness of Mr. Pickwick, part of a bitters bottle, was found in Searsport, Maine. It dates to the 1930s and measures 2" x 1¾".

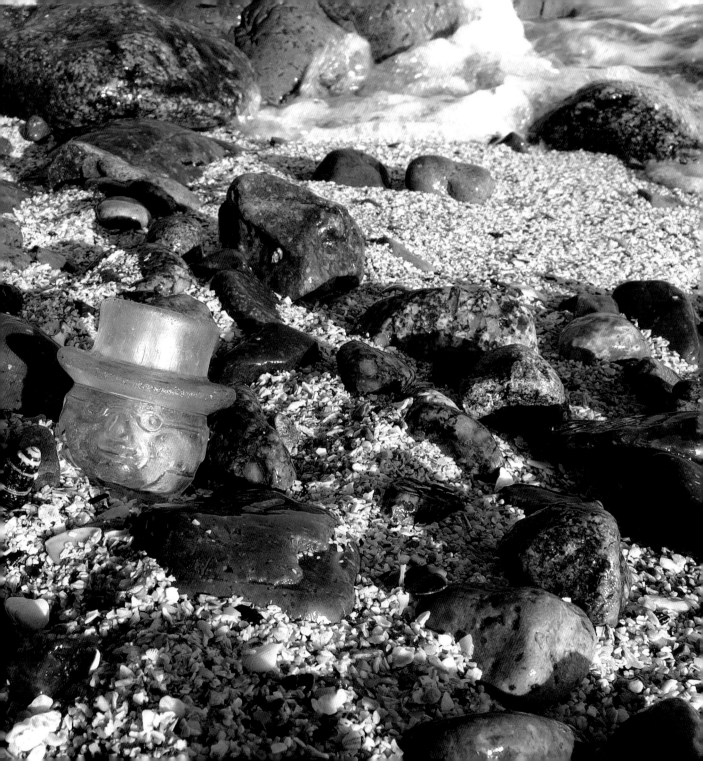

Exquisite Multis

What do a disgruntled poet, 1.5 million tons of industrial waste, and aliens have in common? Seaham, England, of course, home of some of the finest sea glass in the world.

The poet Lord Byron married a local heiress in this small town on the northeast coast of England. Enthralled neither by his wife nor Seaham, Byron wrote to a friend, complaining of "this dreary coast." The dreary coast prospered, however, when a new harbor enabled the transportation of coal; but after decades of tipping waste off the cliffs, nearby Blast Beach took on an otherworldly appearance, seemingly suitable only for extraterrestrial habitation. The makers of *Alien 3* agreed, and filmed on the beach for the 1992 movie.

Aside from aliens and a carved nine-foot statue of Byron at the shopping center, the remnants from a Victorian art glass and bottle manufacturer are the biggest attraction to Seaham. Beachcombers from around the world come in search of "multis"—the name given to the tiny shards, striated in all the colors of the rainbow—that still roll in with the tide.

"Multis" are scraps of fused, colored glass that were snapped off a glassblower's pipe and discarded.

Found in Seaham, England, this multi measures 1" x ¼".

Lips

These lips have nothing to do Phillip's Milk of Magnesia, but the deformity in this sea glass sphere will make anyone smile.

Show most beachcombers a piece of blue sea glass and they'll probably identify it as a fragment from a bottle of an over-the-counter digestive medicine. Charles Henry Phillips, who invented Milk of Magnesia in 1873, is responsible for a lot of the blue sea glass found on beaches throughout the world. His advertising campaigns in the 1930s catapulted his remedy to become a staple in American homes. In one ad, a young woman fretted that she should never have married because her husband "certainly got stuck with a prize dud." She couldn't go to parties without getting ill, but after a dose of Milk of Magnesia, she exclaims, "Today, I'm frisky as a colt, and know I'll be the world's best wife from now on!"

Found on a beach near Galveston, Texas, this shard can be identified by a few letters—"lips"—embossed on the bottle's bottom. It measures 1¾" wide.

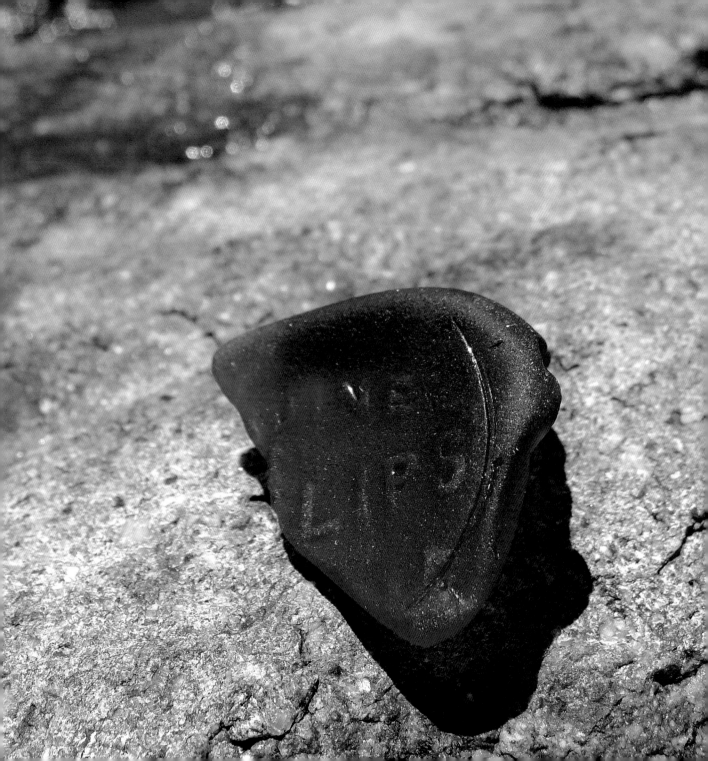

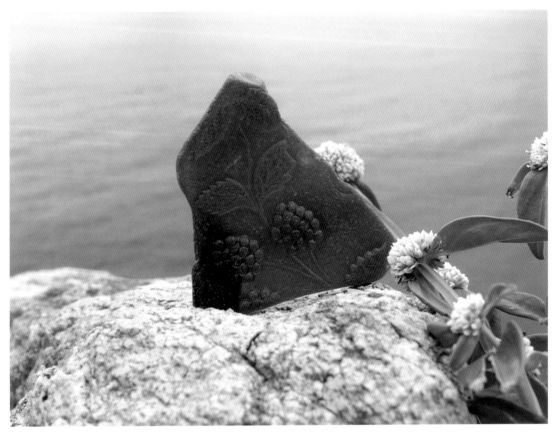

Cobalt blue is one of the most sought after colors of sea glass. This shard dates to the early- to mid-1900s. Found in northern California, it measures 2¼" x 1".

This pattern glass plate or bowl fragment, found in Broadstairs, England, measures 2½" x 1½".

When Nature Won't . . . Pluto Will

Imagery plays a peculiar role in the mercurial success and abrupt demise of Pluto Water, which originated in an Indiana mineral springs in 1848. The embossed figure of a devil on this bottle's bottom represents Pluto—a compassionate or heinous ruler of the underworld, depending on the interpretation of Roman mythology. What is the devil's motive here? Is he hoarding the underground mineral water, or is he offering it up?

Pluto Water became well known in the early 20th century as a cure for a variety of ailments—from arthritis and asthma to malaria and venereal disease. Whether or not Pluto Water actually had any effect on these maladies, the combination of the water's chemical properties—sodium, magnesium sulfate, and lithium salts—does have a natural laxative effect. Magazine advertising at the time vowed, "When Nature Won't, PLUTO Will."

Politicians, movie stars, and the wealthy came to drink and bathe in Indiana's springs, and the production of Pluto Water kept up with the demand. But in 1971, lithium was classified as a controlled substance commonly prescribed for bipolar disorder. You can still bathe in the mineral springs, but buying or selling Pluto Water is now considered a felony.

This bottom from a Pluto Water bottle was found on the Jersey Shore. It measures 2¼" in diameter.

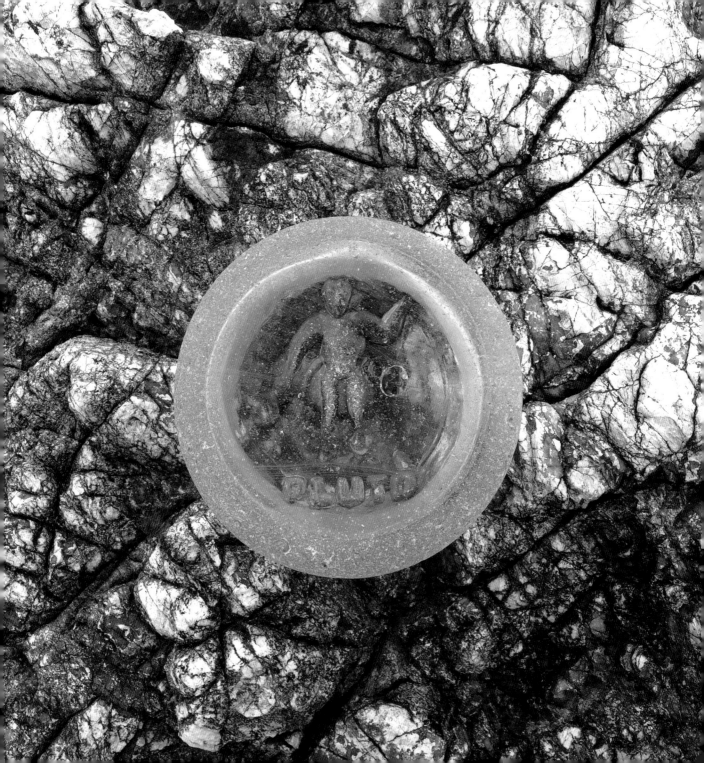

A Teaspoon of Arsenic

In mid-19th-century England, when there were few restrictions on dispensing poison, arsenic was sold in ordinary shops as an inexpensive remedy for vermin and bugs. It was also prescribed as a cure-all for illnesses, including typhus, malaria, and syphilis.

Almost tasteless, arsenic resembles flour or sugar, and, administered in small doses over a short period of time, produces symptoms that mimic heart attacks, strokes, convulsions, and death. As a result, the cause of a person's demise was sometimes misidentified as being due to natural causes, and murder often went undetected. London's Central Criminal Court described these deaths as "a moral epidemic more formidable than any plague." Poison had killed more than a few characters in novels written by Victorian authors Edward Bulwer-Lytton, Charles Dickens, Arthur Conan Doyle, George Eliot, and J.B. Lippincott. The plots were nearly do-it-yourself guides and probably inspired a few actual murders. American playwright Joseph Kesselring spoofed death by poisoning in *Arsenic and Old Lace*. One of his leading characters states, "For a gallon of elderberry wine, I take one teaspoon full of arsenic, then add half a teaspoon full of strychnine, and then just a pinch of cyanide."

This poison bottle, found in a Californian canal, measures 2½" x ¾".

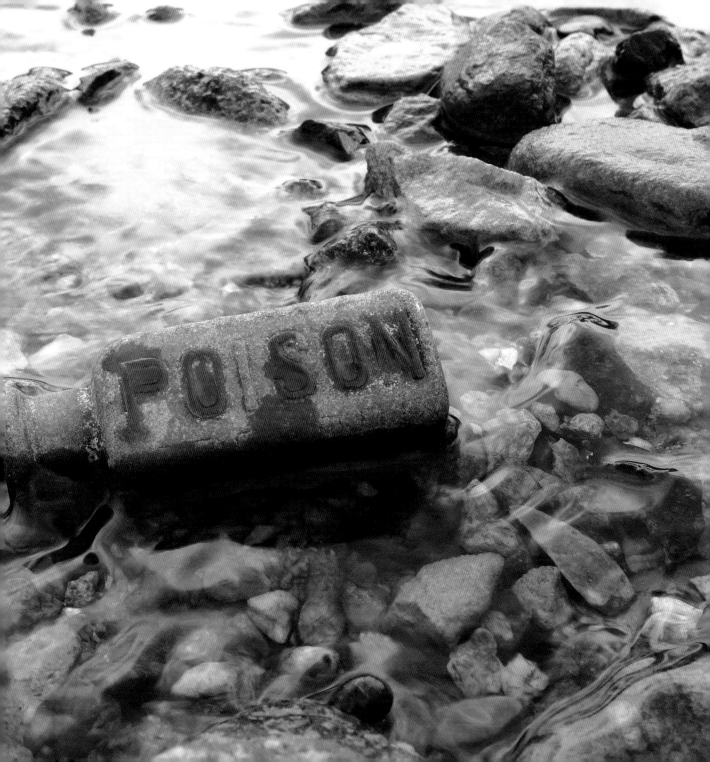

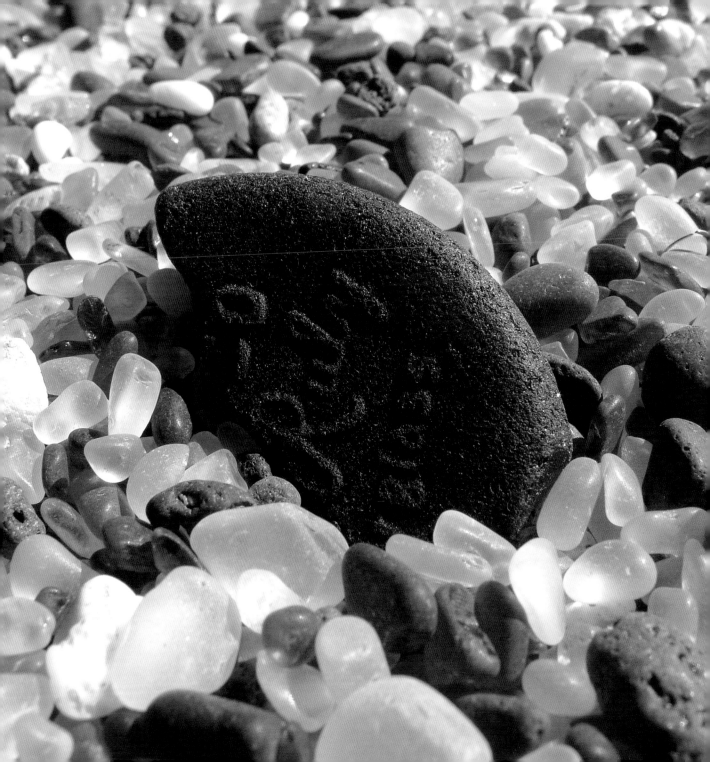

Color Fit for a King

Legends and strange beliefs have surrounded the ruby gemstone for centuries—its deep red color is said to inspire passion, offer wisdom and wealth, and protect against the plague. Ancient Hindus offered rubies to the god Krishna in hopes of being reborn as emperors. And in 1300, Marco Polo referred to the "world's finest ruby" when he reported that Kublai Kahn had offered the King of Ceylon "the value of a city" in exchange for a ruby that "measured the length of a man's palm and the thickness of his arm." And 10th-century Persian physician and philosopher Muhammad ibn Zakariya al-Razi created a formula for red glass—adding gold to the mix.

Fast-forward to the middle of the 20th century, when Anchor Hocking created a limited edition red bottle, known as Royal Ruby, for the Schlitz Brewing Company. Schlitz was the largest brewery in the United States at the time, and had previously used only traditional brown bottles. Although Anchor Hocking replaced the gold with copper oxide in its Schlitz bottles, the glass retained its unmistakable ruby color. Schlitz sold 54,000,000 Royal Ruby beer bottles between 1949 and 1963.

Red sea glass is so rare, some beachcombers have never found it.

The bottom of a Schlitz Royal Ruby bottle, found in Hatillo, Puerto Rico, measures approx. 2⅛" in diameter.

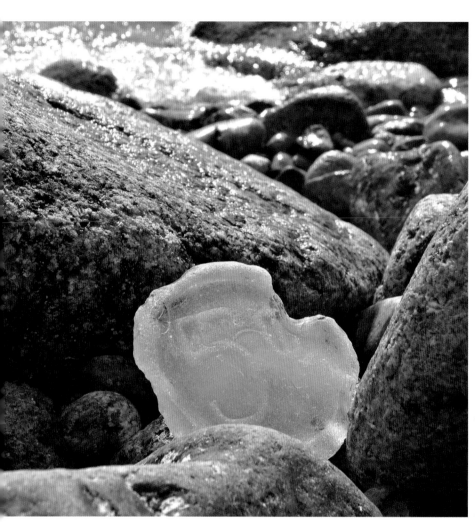

The deposit—5 cents—for this circa 1930 Thatcher's milk bottle is embossed on the bottom. It was found in the Whitewater River in southern Indiana—not all sea glass comes from the ocean. It measures approximately 3¼" in diameter.

Not delicate candies or perfumed soaps, these bottle bottoms were found on beaches all over the world.

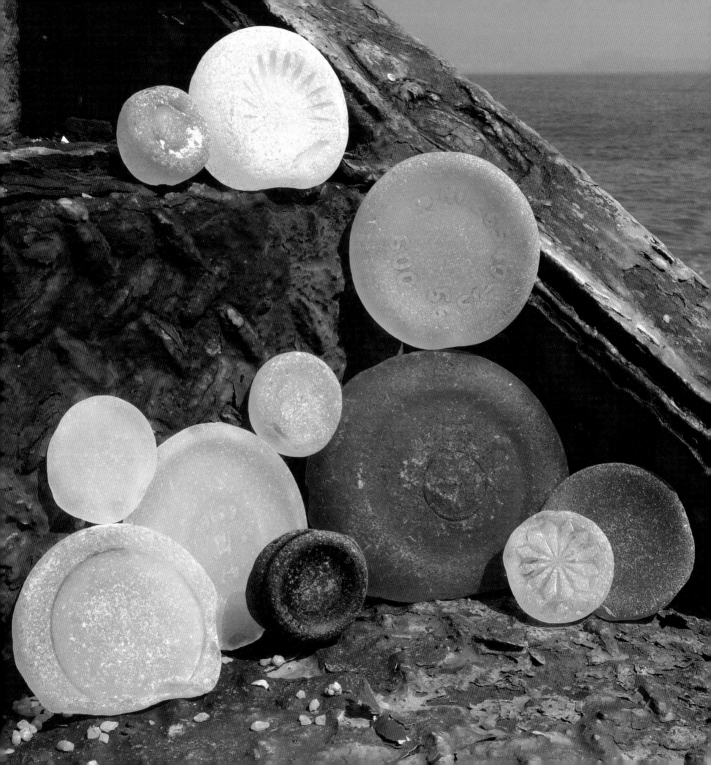

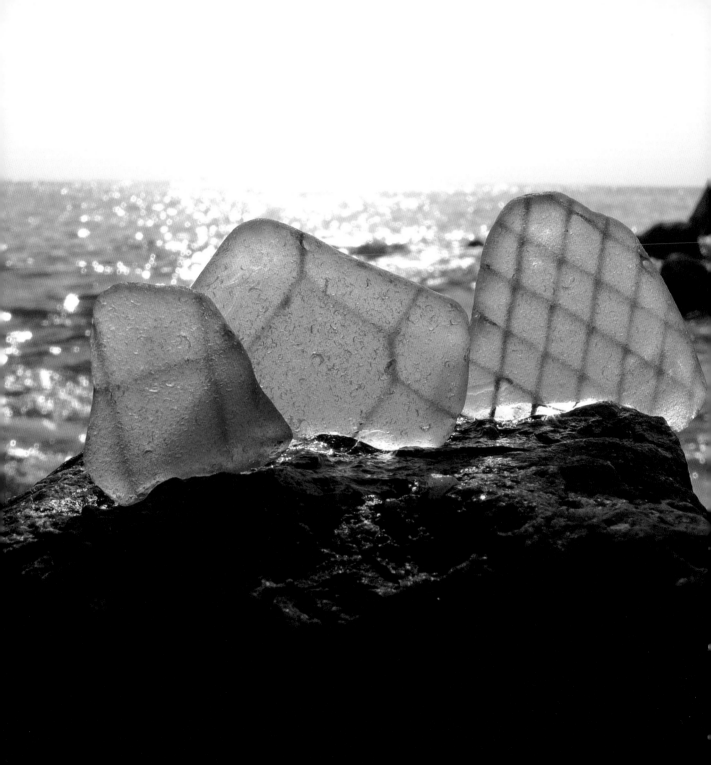

Steam Punk

Since its invention in the late 1800s, safety glass has been called everything from practical to hazardous to fashionable. This fusion of wire mesh between two panes of tempered glass revolutionized the window manufacturing industry. Designed to prevent glass from shattering from extreme heat or stress, safety glass has been widely used in schools, hospitals, and recreation centers. In 2006, however, the United States International Building Code declared that safety glass is less stable than unwired glass.

With the onset of "steam punk," industrial technology from the late 19th and early 20th centuries has become popular. As a result, reproductions of safety glass have become trendy architectural statements in urban restaurants and lofts.

Another piece of turn-of-the-century industrial tech, this electrical insulator—H.G. Co., Heminray No. 21—predates porcelain insulators.

Auld Lang Syne

As early as the 15th century in Milan, Italy, members of the upper class would toss candy and flowers to the masses as they passed through town. Paper confetti appeared during New Year's Eve celebrations in late-19th century Paris. Today, on New Year's Eve in New York, a so-called Confetti Master and a crew of seventy drop more than a ton of the stuff from buildings overlooking Time's Square.

Spatter glass seems to express the random joy of a brightly colored confetti storm. Unlike other forms of blown glass, spatter glass is created when opaque molten glass is rolled over a heated metal plate covered with small chips of crushed colored glass, and then free-blown or transferred into a mold. The finished piece has the colored chips permanently embedded.

Found in Argyll, Scotland, and probably made in Czechoslovakia in the 1930s, this shard may have originated as a vase. It measures 1¾" at its widest.

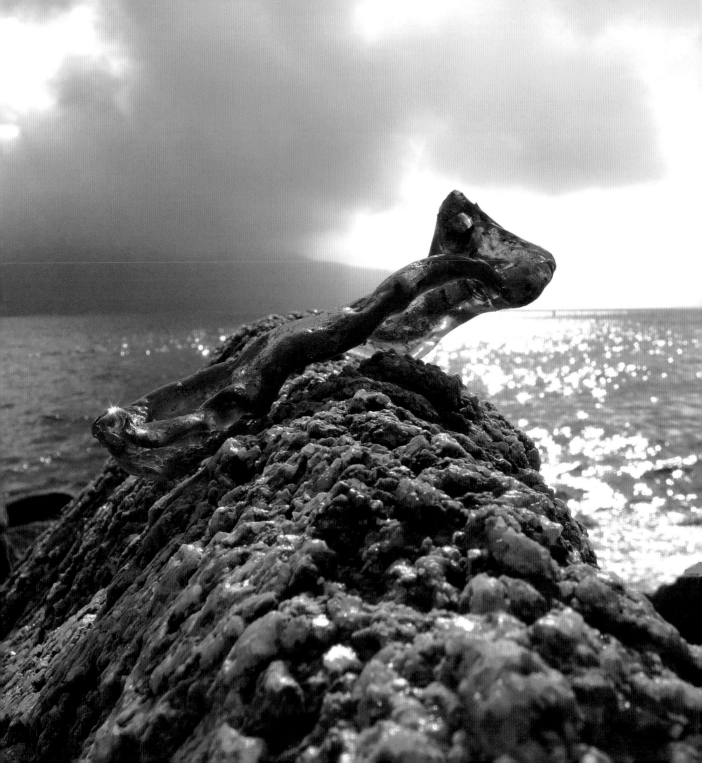

Out of the Ashes

Bonfire glass doesn't show the outward beauty of traditional sea glass with rounded edges and frosted surfaces. Instead, bonfire glass sags, slumps over on itself, sometimes trapping and fusing other bits of glass, sand, pebbles, and other debris around it. This transformation occurs when solid glass is partially melted in a hot fire. It doesn't become pure liquid, but is more viscous and oozes into strange shapes before cooling and re-hardening. Variables such as composition, thickness, purity, as well as the temperature of the fire all contribute to the final result.

Bonfire glass is evocative of 1960s beach-themed movies, such as *Blue Hawaii* and *Beach Blanket Bingo*, in which the beach sets the scene for summer romance. The most common sources of bonfire glass—beer and soda bottles—melt at approximately 1,800 degrees Fahrenheit. Of course, it then must be carried out to sea and spend years in the surf before it becomes sea glass.

These shards were found in northern California, Puerto Rico, Staten Island, New York, and Gloucester, Massachusetts.

Found in North Carolina, this bonfire glass measures 4" x 1¾".

Old Mr. Boston

When the Old Mr. Boston Distillery opened in 1933, the post-Prohibition party had already begun. Rum, bourbon, gin, vodka, and liqueurs sold well, due in part to the fictitious Mr. Boston, who headed the company's advertising campaign. In 1935, the distillery published *Old Mr. Boston, Official Bartender's Guide*, which contained a few abbreviated history lessons on Plymouth Rock, Paul Revere, and the Boston Tea Party. The little book has sold more than 11 million copies. In 2015, *Punch* magazine proclaimed that Old Mr. Boston "conveyed authority, quality and heritage, never mind that he was sorely lacking in all three. With top hat and muttonchops, he was a sort of human Mr. Peanut, minus the monocle."

This fragment of an Old Mr. Boston bottle found near Galveston, Texas, measures approximately 1¾" x 2½".

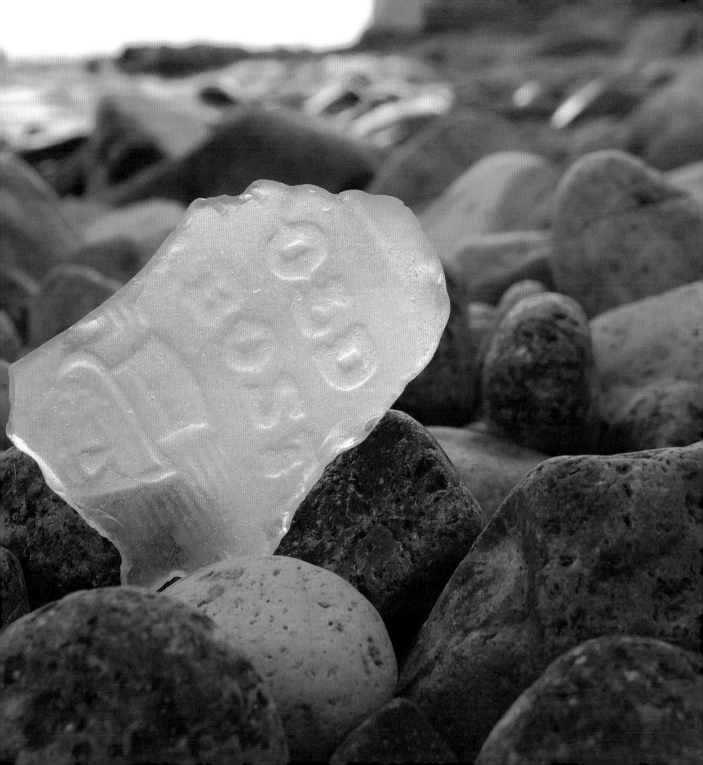

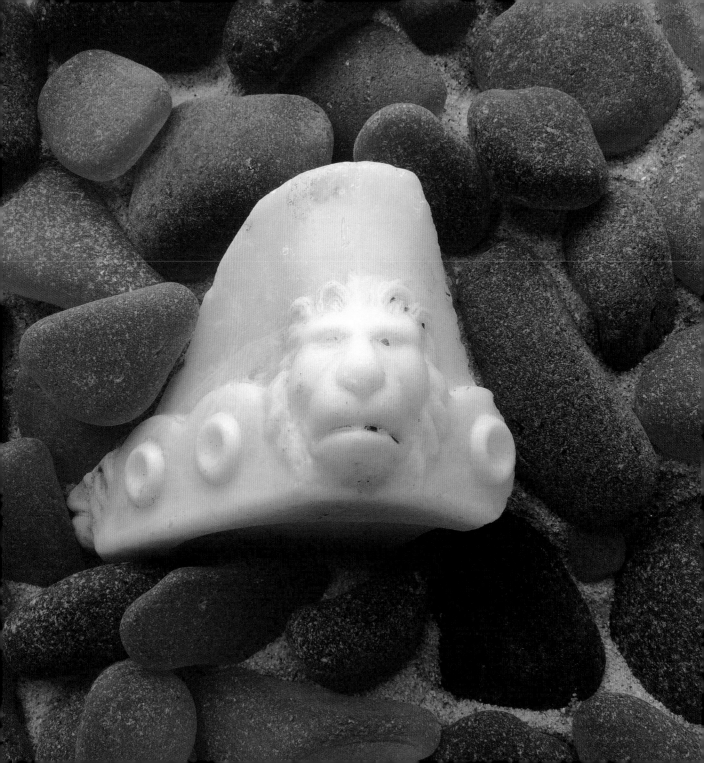

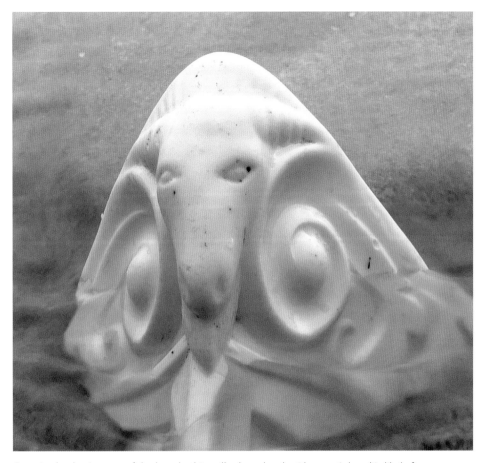

Seemingly plowing out of the beach, this milk glass shard, with a ram's head is likely from a planter or a compote. Measuring 3" x 2½", it was found in Sussex, England.

Originating in 16th-century Venice, milk glass is opaque or translucent glass that was made into a wide variety of objects. The term is somewhat deceiving because milk glass isn't always white and in fact was made in a wide variety of colors, though white is the most common. This 1½" x 2½" shard with a lion's molded face probably came from a footed dish or planter.

This beautiful orange multi was found in Seaham, England.

Impossibly Orange

The rarest color of sea glass is transparent orange—not carnival glass, with its shiny, iridescent surface; not milk glass, which is opaque; and not amberina, with shades of red merging with amber. The key ingredient for transparent orange glass is cadmium, a heavy metal by-product of zinc mining, discovered in 1817. According to the report, "Trends in Usage of Cadmium," by the National Research Council's Committee on Technical Aspects of Critical and Strategic Materials, one ton of zinc produces 6.5 pounds of cadmium. No doubt, because of the scarcity and cost, few orange-colored glass items were made.

This shard probably originated as a 1930s blown glass vase from Czechoslovakia. It measures approximately ¼".

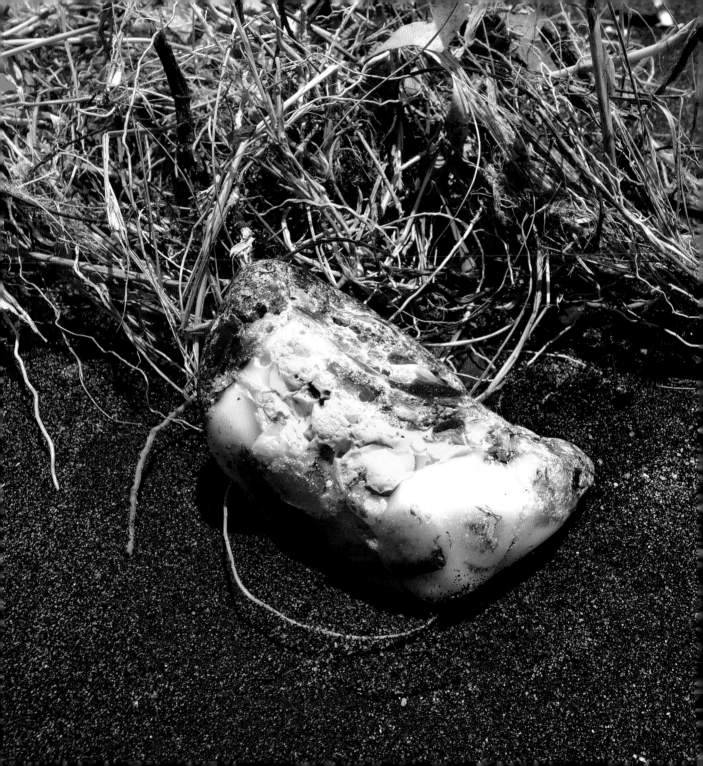

Friggin' Around

Beginning in the 18th century, European glassmakers created one-of-a-kind objects known as friggers, end-of-day glass, and whimsies. Made from molten glass that remained in the pot at the end of workers' shifts, most friggers were purely decorative. However, some friggers were reputed to have special powers, and people believed they would protect against witchcraft or prevent disease by killing germs.

A composite of leftover colors from a day of glassmaking, this large shard, called a "frigger," measures 3" x 1¾".

Glow-in-the-Dark Glass

It's not magic, but a certain type of sea glass that, when exposed to black light, shines luminescent. Uranium glass, also known as ultraviolet glass and Vaseline glass, contains trace amounts of radioactive uranium, which is what gives this glass its otherworldly glow. Used as a colorant since the mid-1800s, the uranium in everyday glasses and dishes is radioactive and will register positive on a Geiger counter. But the two-percent content is considered harmless—equivalent to current television and microwave emissions. However, the United States Environmental Protection Agency warns that consuming acidic food or drinks from abraded or chipped uranium glass can be harmful over time.

Uranium glass actually only "glows" under ultraviolet light. These shards were found on beaches all over the world. (Carlie Cloyd photo)

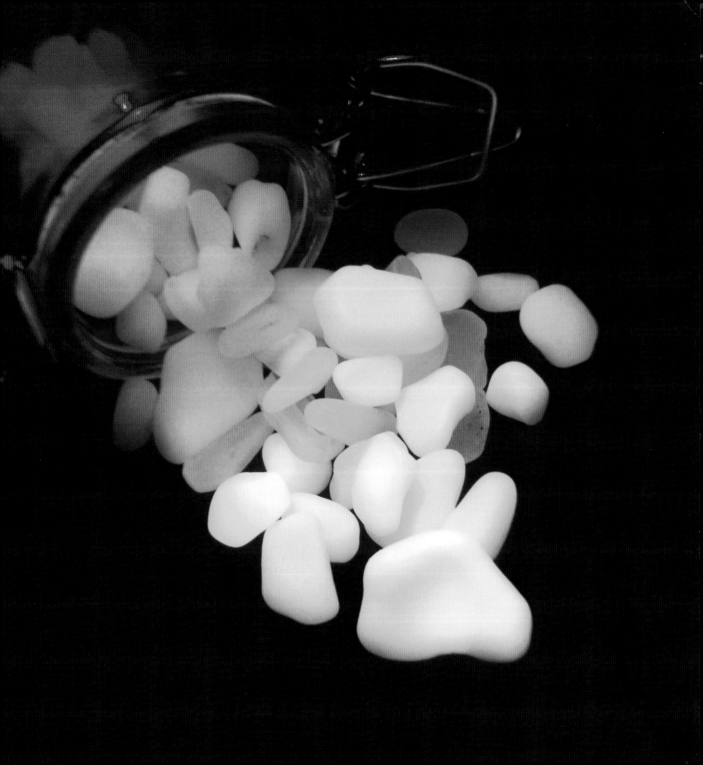

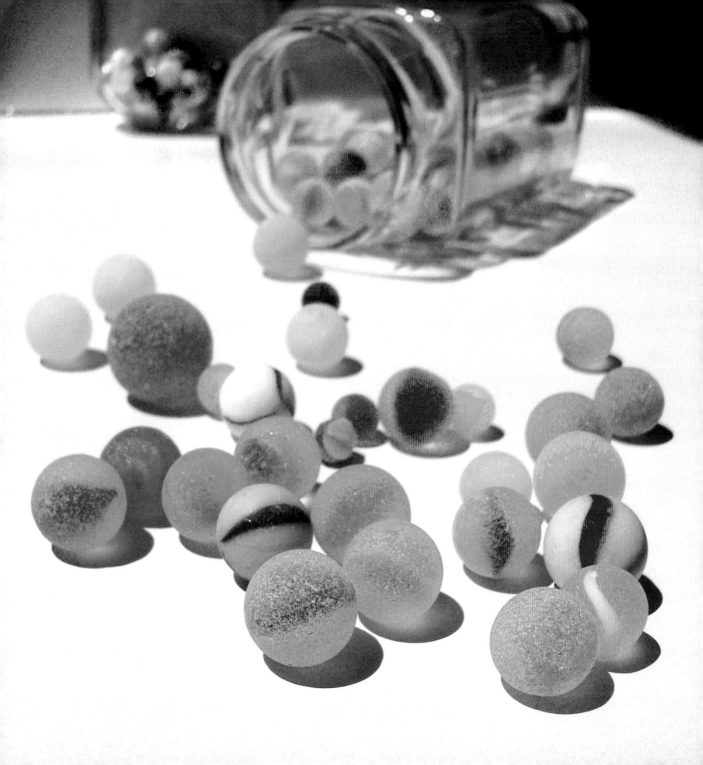

Over time, salt water draws out soda and lime from the glass and gives it a pocked and opaque surface. This shard looks like a frozen planet with swirls of white clouds. It was found in Seaham, England, and measures about 1½" in diameter.

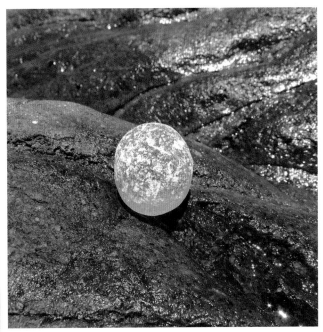

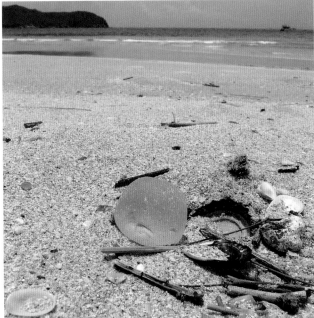

Not all round pieces of sea glass come from Codd bottles. This yummy-looking gum drop, in rare yellow, is much too large. Found on the Jersey Shore, it measures 1½" x 1¾".

And sometimes round sea glass can be children's toys, like these marbles.

Kick-ups

These kick-ups or punts once belonged to wine and liquor bottles. Originally part of the glassblowing process, a thick lump or a shallow, convex bottom was created to ensure the bottles would stand erect. While some theories suggest that kick-ups in molded bottles add stability and strength, help trap sediment, or possibly help sustain the pressure in sparkling wines, generally bottles have them today because of tradition.

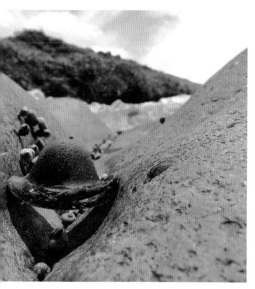

Not a crashed UFO, this is a kick-up, or punt, from a wine bottle tossed to the waves long ago.

These weird green blobs are the pushed-up bottoms of wine and liquor bottles.

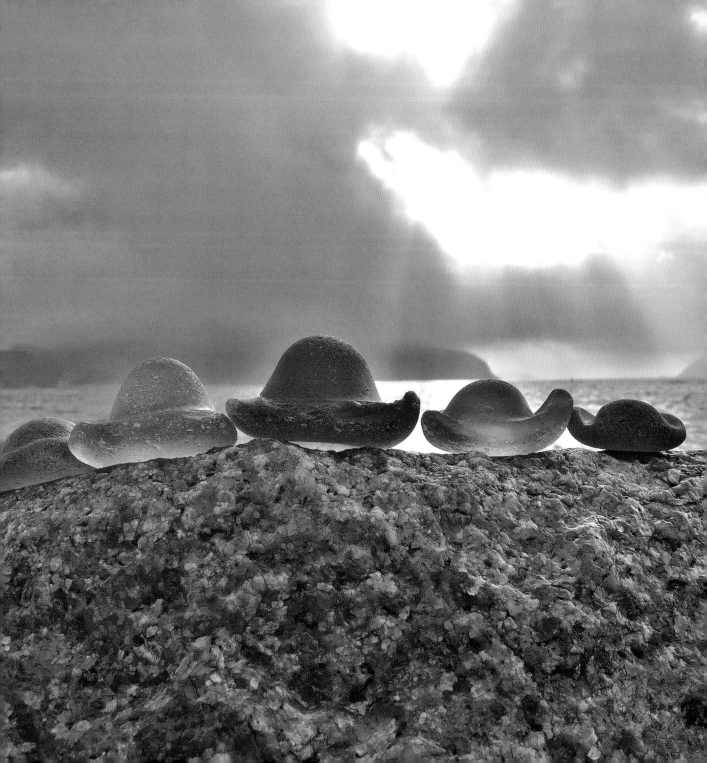

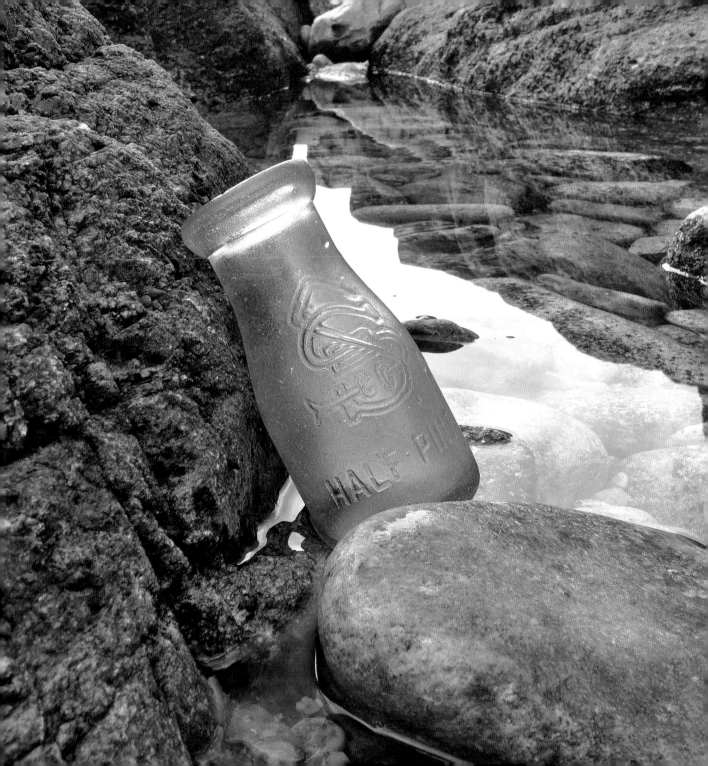

Milk Wars

In New York City during the 1930s, Borden's Condensed Milk Company, Sheffield Farms, and U.S. Dairy Products Company held a monopoly over the city's milk supply. Smaller, independent farmers in New York, as well as throughout the rest of the country, couldn't compete, and milk distributors paid these farmers less for their milk than it cost them to produce it. In response, the Dairy Farmers Union encouraged strikes, often violent, throughout the country. According to an article in *The New York Times* in 1933, what became known as the Milk Wars, "possibly brought New York State closer to Marshall Law than at any time since the Revolutionary War." It's rare to find an intact bottle of any sort on the shore.

This amber shard is not from a milk bottle; the embossed portrait of Harry Wilken Sr. comes from a Wilken Whiskey bottle, circa 1930s. Found in Broadstairs, England, this shard measures 1¾" x 1¼".

This milk bottle, embossed with "4 Sheffield Farms Lawson Decker Co New York" on one side, and the company logo and "Half Pint" on the other, dates to the early 1900s. It measures 5½" x 2½".

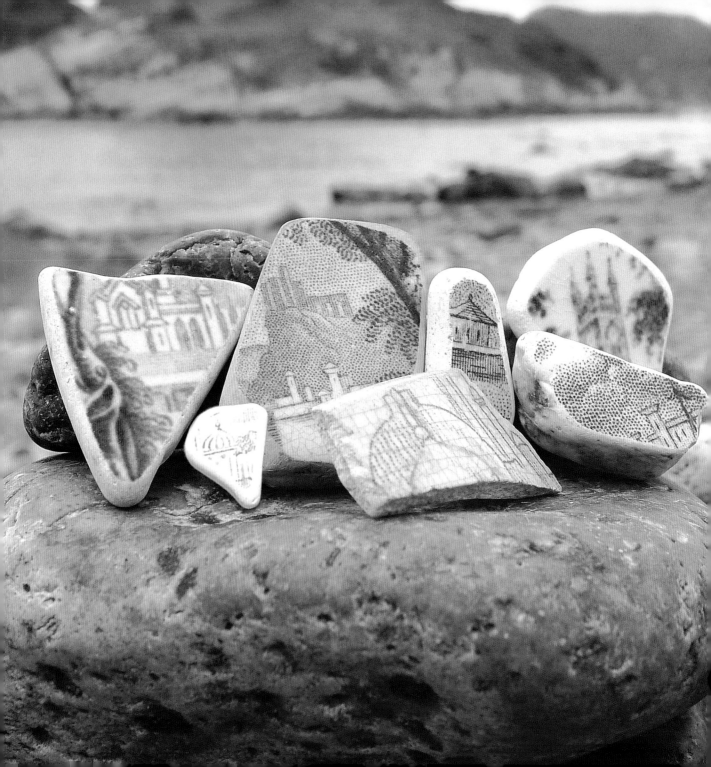

2

An Altered Universe

If these pottery shards could talk, they would reveal stories through languages as diverse as delicate French porcelain and graceless chunks of Egyptian crockery. These fragments invite beachcombers to sift through time and enter other universes.

The rarest pottery shards appear to be detailed pen-and-ink drawings, but they are, in fact, images copied from 18th- and early 19th-century book illustrations that featured people, exotic animals, castles, and plant-life. Salinity, abrasion, and other physical and chemical factors break down pottery more rapidly than glass. Because pottery is porous under applied glazes, barnacles, rust-colored stains, deep scratches, and crazing easily scar the pottery's surface.

As the ocean slowly consumes the partial words on pieces of an early pipe bowl, a teacup's chintz pattern, or a ghostly face on a jug, the tiny worlds they represent fade away.

The ocean transports sea glass and pottery shards—abandoned pieces of history that tell us something about ourselves, no matter where we live or who we are.

Yes, these little adobe huts are sea glass, porcelain insulators from electrical lines.

A Shard Fit for a Cardinal

This stoneware shard, part of a Bartmann (from the German "bearded man") jug, dates to the late Middles Ages in Europe. The image is believed to have originated from mythical wild men, similar to those that appeared in Chaucer's *The Canterbury Tales*.

Another popular theory claims that the image resembles Italian Cardinal Robert Bellarmine and was created to ridicule him. Among his many controversial decisions, Cardinal Bellarmine insisted that astronomer and mathematician Galileo recant his findings and accept that the earth is stationary and that the sun moves around the earth. Shards of Bartmann jugs have been found at the wreck sites of England's *Sea Venture*, lost in 1609 in Bermuda, and King Henry VIII's warship, *Mary Rose*, sunk off England's Isle of Wight in 1545.

This shard, probably from a tavern pitcher, was found on the Thames River foreshore, London. It measures approximately 1½" by 1¾".

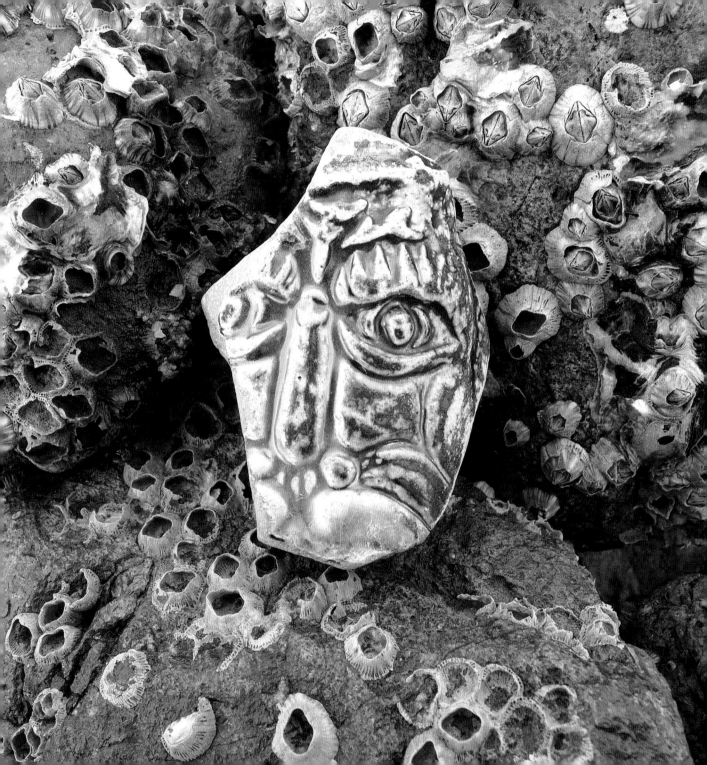

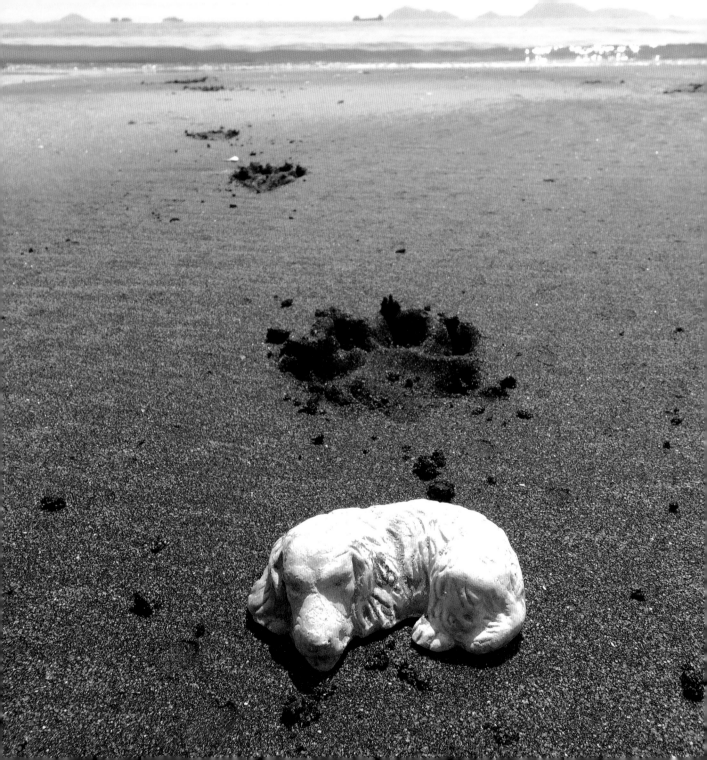

A Prize of Chalk

Chalkware figurines, also known as carnivalware, were given out as prizes in arcade games-of-chance from the 1930s to the 1960s. Made of molded chalk or plaster-of-Paris, the most popular figurines—Popeye, Betty Boop, and Kewpie dolls—were often decorated with glitter and feathers. Because chalkware is so fragile, survivors are usually worn down and chipped. This type of little dog, probably an imitation of an expensive English bone china statuette from the early- to mid-1900s, is known as "the poor man's Staffordshire."

Speaking of dogs, this porcelain tea-cup shard emblazoned with a greyhound was found in Portsmouth, New Hampshire, and measures 1½" x 2".

Found in Rockport, Maine, this chalkware dog measures approximately 2" x 1¼".

Spiritual Smoke

Before Sinclair Lewis wrote *Elmer Gantry*, a satirical novel about evangelism, there was Auguste Henri Jacob (1828–1913). A larger-than-life French spiritualist healer, Jacob had been discharged from the French army because his followers constantly disrupted daily military activities. Jacob claimed that spirits had granted him the power to heal the sick by staring and laying his hands on the patient during periods of silence. According to newspaper reports at the time, Jacob cured fifteen out of twenty patients, and had his greatest successes before large audiences.

Printed with "Bon Fumeur" on one side and "Tabaco" on the other, this 4½"-long pipe stem dates to the early 1900s. The bowl (not shown) depicts an African man's head.

Probably made between 1850 and 1920 by Gambier, one of the largest pipe makers in France, this Henri Jacob pipe bowl was found on the River Thames foreshore in London. It measures 1" x 2¼".

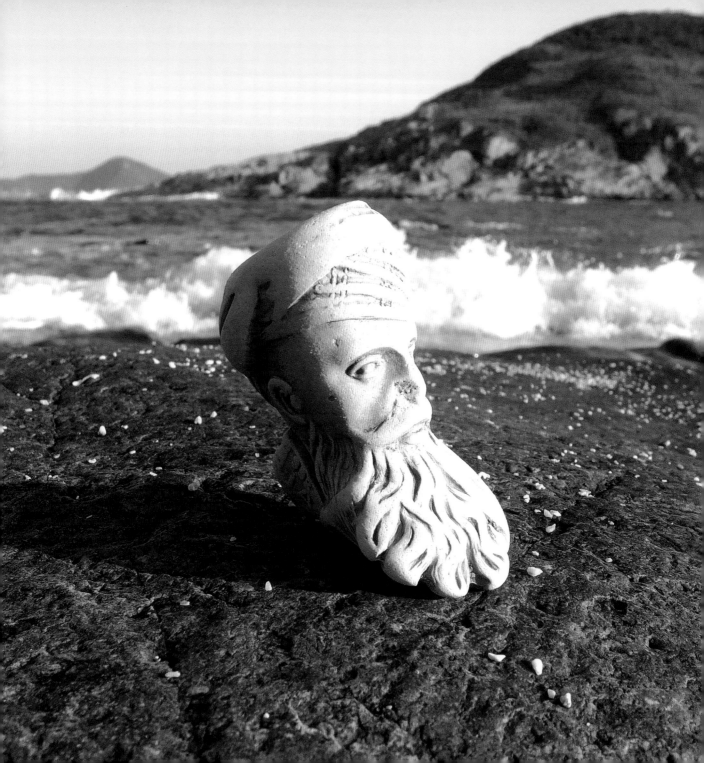

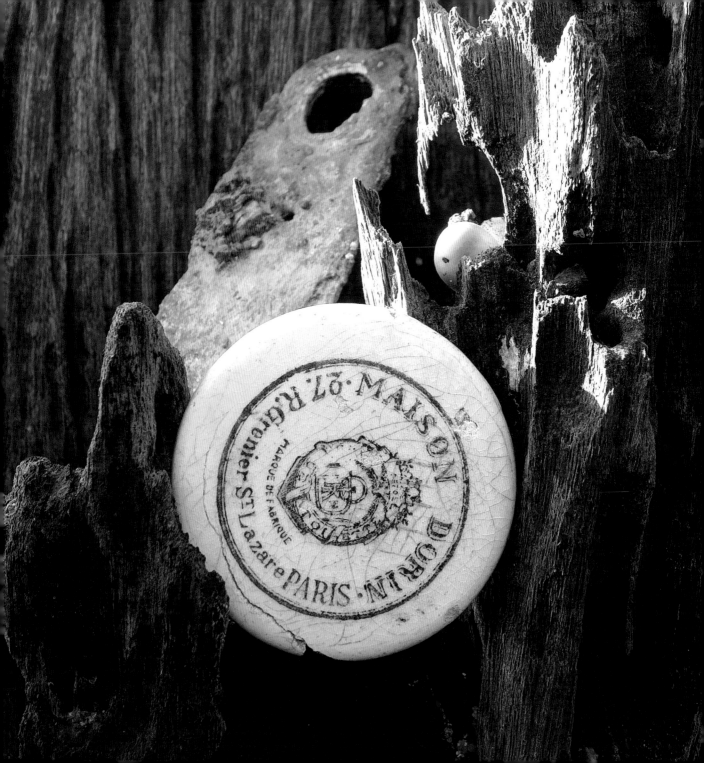

Marie-Antoinette's Makeup

During the reign of France's Queen Marie-Antoinette, four-foot-tall powdered wigs decorated with model ships, birdcages, and small wax figures became the symbol of excess for the French aristocracy. Fashion dictated heavy white makeup, rouge-covered cheeks, and velvet beauty marks in shapes of moons, stars, and hearts.

In her book, *Le Poudre et le Fard,* about the history of cosmetics, Catherine Lanoë states that by 1781, French women used about two million pots of rouge each year. Paris's Maison Dorin, which specialized in powders, creams, rouge, and perfumes, had been named the official supplier to the Court of Versailles.

This 2¼" porcelain shard, part of a Maison Dorin rouge pot, was found along the Susquehanna River in Luzerne County, Pennsylvania.

Butter or Margarine

In 1895, an argument over a lump of margarine made it to London's High Court and challenged the nuances of England's Margarine Act of 1887. It started when an officer of the Pure Butter Association entered Pearce's Dining and Refreshment Rooms, which were known as "places for the working classes and industrial classes." The officer asked for four dry slices of bread and three pennyworth of butter, and the clerk cut off a piece of a yellowish lump that was behind the counter.

The clerk insisted that he would put any amount on the bread, but that it could only be consumed on the premises, and was not for take-out. The officer explained that he wanted it for analysis to see if it met the requirements of the Margarine Act, which stated that butter and margarine for sale must be labeled separately. The officer filed a complaint against Pearce's Dining and Refreshment Rooms. After a lengthy trial, the restaurant won on a technicality—the shrewd placement and interpretation of a sign that read, "Nothing but a mixture of the best Danish butter and margarine is sold at this establishment."

This fragment of a dinner plate, found near Chatham, England, measures approximately 1½" x 1¾".

PEARCE

DINING & REFRESHME

ROOMS

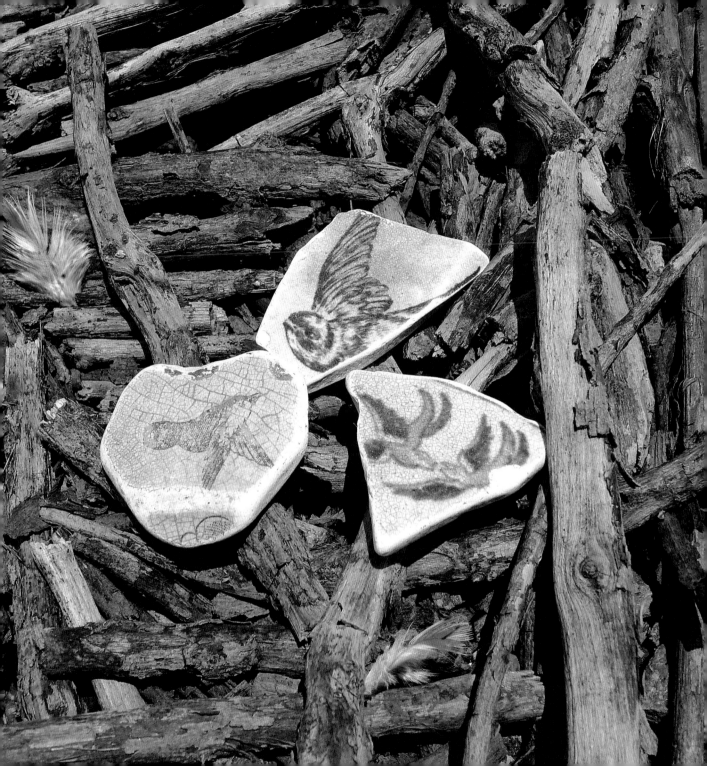

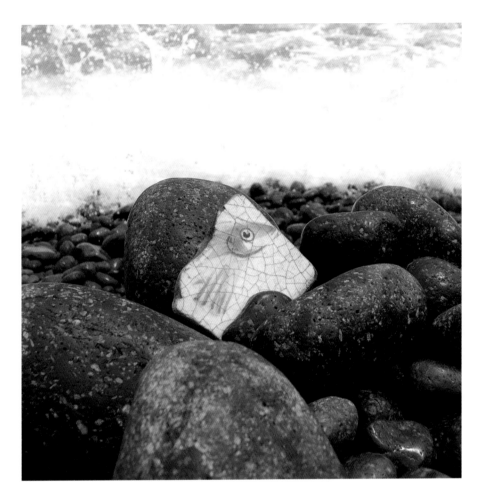

Found in London, in the River Thames, this hand-painted tile shard featuring a fish measures 2½" x 2".

One of England's greatest poets, William Wordsworth, was instrumental in launching the Romantic Age, known for its celebration of nature; and the majority of his work focused on that theme. These shards featuring birds were all found in Wordsworth's stomping grounds of Cumbria, England.

Knights and Unicorns

The Warwick China Manufacturing Company, in production from 1887 until 1951, has a colorful history. It was located in a thriving red-light district in Wheeling, West Virginia, and according to company records, some of the girls pictured on their china were ladies of the night. Warwick's images of Native Americans and monks are highly sought-after today, too.

The company also produced more mundane china with hotel and restaurant logos. However, the image of Bartholomew Richard Fitzgerald-Smythe, a.k.a. "Mr. Peanut," appeared on their china pattern at the 1939 New York World's Fair. The company logo is said to have been inspired by England's Warwick castle and its elegant ties to the age of knights and chivalry.

If you believe in unicorns, you're not alone. Sightings of a white horse with a single horn protruding from its forehead have been recorded from the 4th century B.C. Britain's royal coat of arms even features a unicorn, and this shard bears part of that seal. Found in Cumbria, England, it measures approximately 1½" x 1¼".

This shard, bearing the Warwick emblem of a knight and crossed swords, measures 1¼" x 1".

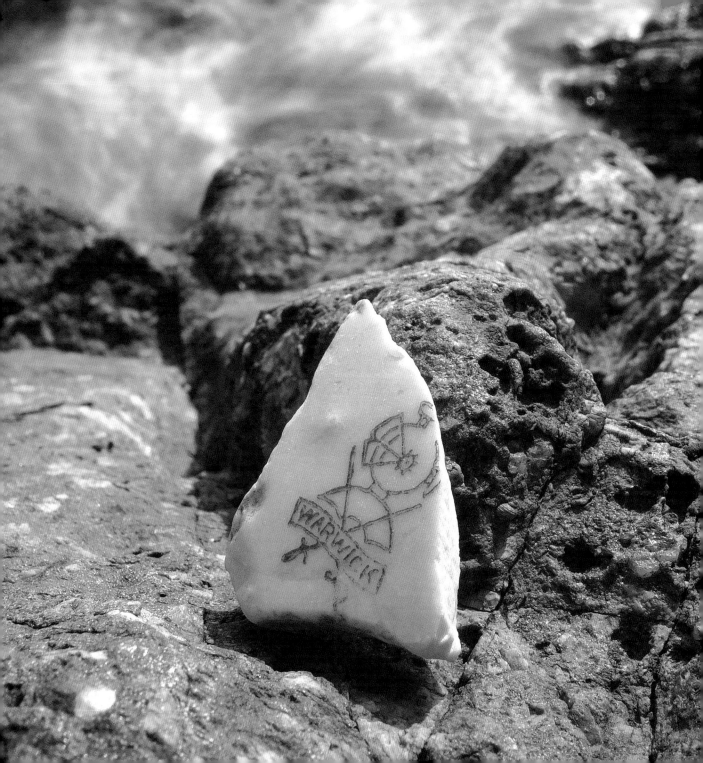

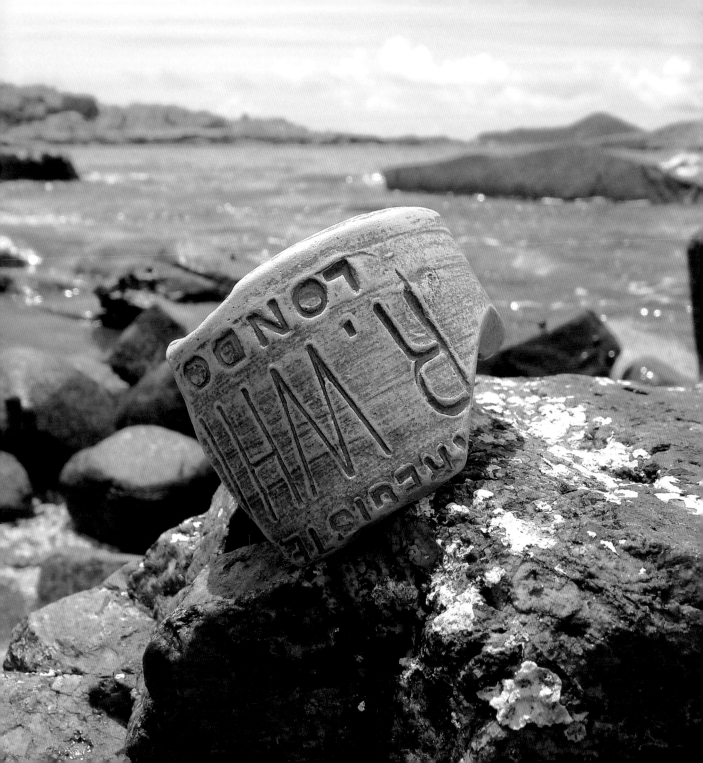

Ginger Beer

Traditionally known for its medicinal properties, ginger has been consumed for more than 5,000 years. In London in 1845, Robert White and his wife began brewing the first ginger beer. The combination of ginger, water, sugar, and a bacteria called "ginger beer plant" results in a fizzy, carbonated soda; but when mixed with beer or rum, ginger beer becomes an alcoholic beverage.

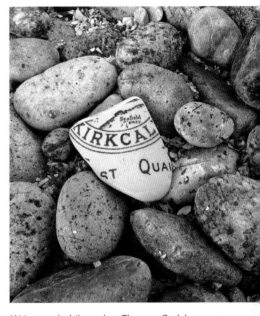

Writer and philosopher Thomas Carlyle described Kirkcaldy, Scotland, as "a mile of the smoothest sand, with one long wave coming on gently, steadily, and breaking into a gradual explosion into harmless melodious white." This fragment of a Kirkcaldy ginger beer jar shows the image of the 16th-century Seafield Tower. Found in Kirkcaldy, it measures 1½" x 1¾".

This Victorian-era stoneware shard bearing the name of ginger beer inventor Robert White was found in Kent, England, and measures 2¾" in diameter.

Frozen Charlottes

Manufacturers of small china dolls known as "Frozen Charlottes" were inspired by a true story in 1840 from the *New York Observer.* A young woman named Charlotte refused to cover her elegant gown during an ice-cold sleigh ride to a winter ball. She ignored her mother's advice to choose practicality over vanity, and, as a result, Charlotte froze to death on the journey.

Moved by the story, a journalist wrote the poem, "A Corpse Going to a Ball," which later became a ballad with the less morbid title, "Young Charlotte." The ballad was enormously popular in America, Germany, and France, and dollmakers seized the opportunity.

They created small china dolls made in single molds and with no moving parts. The tiny dolls could float in the bathtub or be baked inside cakes as a holiday surprise. Some Charlottes came in little metal coffins. They served as a cautionary tale—"children should listen to their parents." And as a subtle reminder, Charlottes were actually frozen in ice and used to cool cups of tea.

That young woman who died in the mid-1800s has been eulogized in modern times in Pete Seeger's "Young Charlotte," and in Natalie Merchant's rendition, "Frozen Charlotte."

This Frozen Charlotte, found in Gloucester, Massachusetts, is 1" tall.

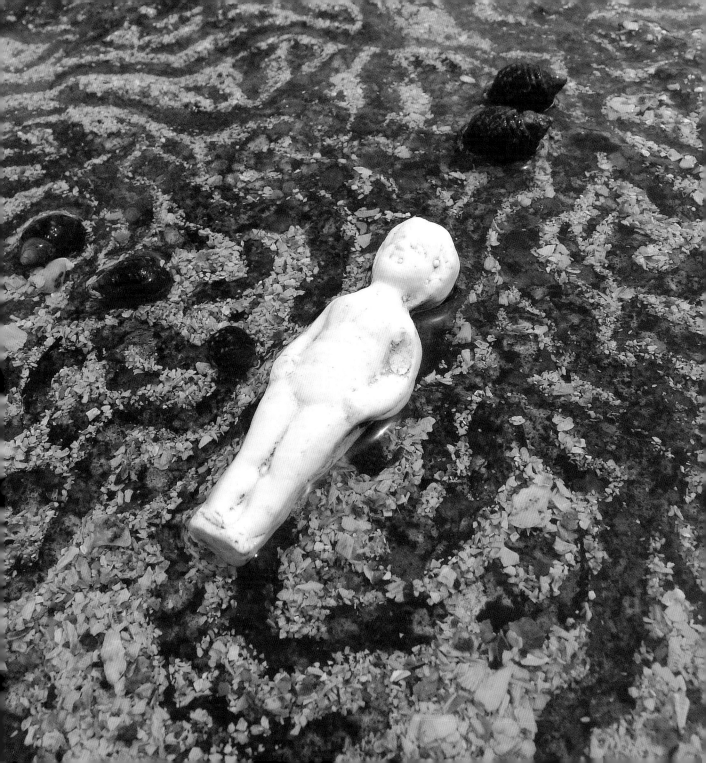

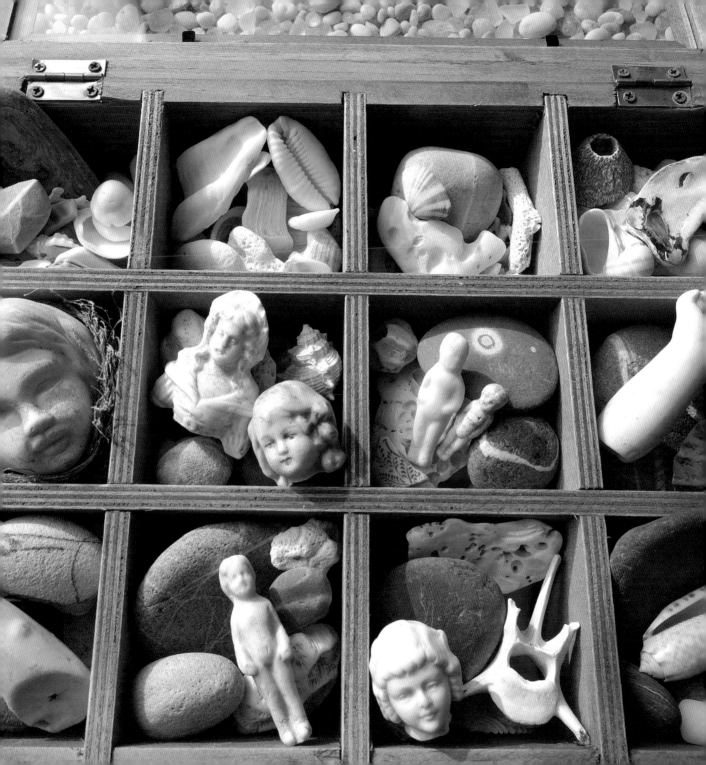

Spare Parts

German and French companies produced the majority of china dolls for export between 1836 and the 1940s. These dolls often reflected contemporary fashions, including the hairstyles of famous people, such as Queen Victoria, Mary Todd Lincoln, and Jenny Lind.

Facing page, row two, square one: unidentified; square two, bonnet head and Dolly Madison; square three, Frozen Charlottes; square four, arm that would have been attached to a cotton or leather extension to the doll's body. Row three, square one: articulated leg; square two, Frozen Charlotte; square three, Spill Curl Head.

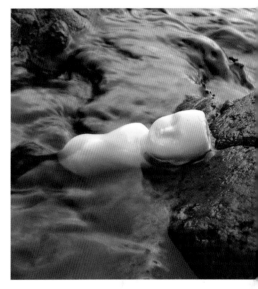

As collectible as they are, it can be disconcerting to come across a china doll cast forlornly on the shore.

Notice how the ravages of the sea have softened the details of these china dolls, because china and pottery wear much faster than glass.

Chinamania

In response to the large, gilded mirrors and dark, heavily carved furniture of the Victorian Era, simpler Chinese fabrics, paintings, and blue-and-white porcelain began to flood European markets. Popular interest in the fresh, exotic fashion became known as "Chinamania," and was emblematic of the Aesthetic Movement's "art for art's sake."

Oscar Wilde decorated his rooms at Magdalen College with Chinese blue-and-white porcelain, peacock feathers, and calla lilies. The playwright, poet, and novelist, perhaps in a moment of dark humor, said, "I find it harder and harder every day to live up to my blue and white china."

This shard, found on Prince Edward Island, Canada, measures 1¾" x 1".

Found in Kirkcaldy, Scotland, this shard measures 1½" x 1¼".

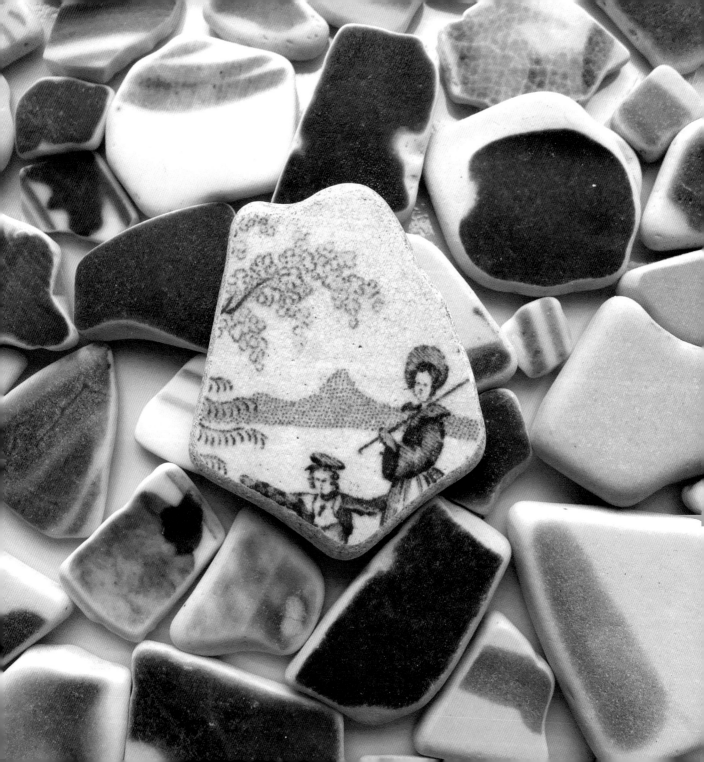

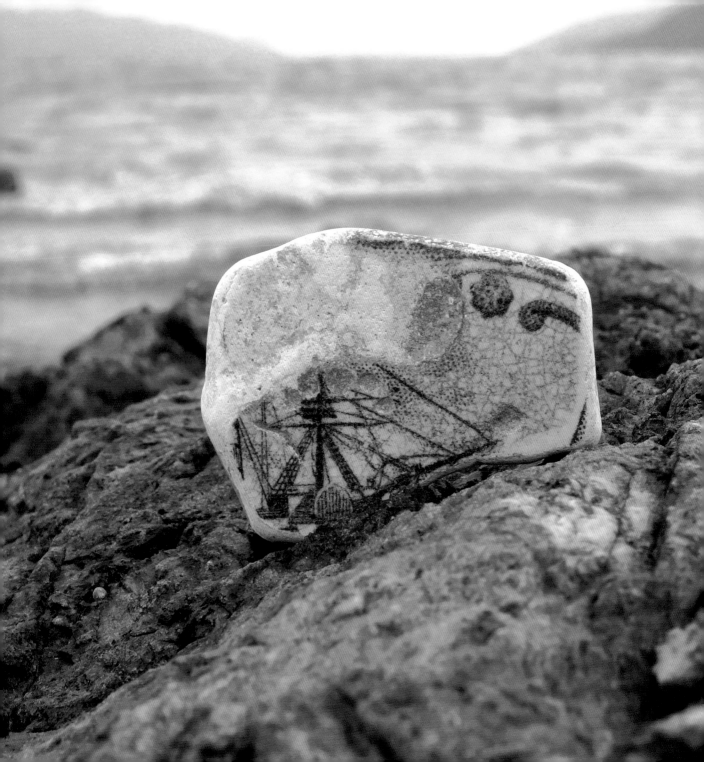

Mooncussers

Sensational stories abound of incidents from the 18th and 19th centuries along England's Cornish coast, where rocks in hidden coves create the perfect setting for shipwrecks. Members of the fishing and mining communities used lanterns to imitate the stern light of another ship, and many merchant captains set their course by the false light, believing it showed a safe route ahead.

In her novel *Jamaica Inn*, Daphne du Maurier wrote, "It's lights a vessel looks for, when she's seeking harbour. Have you ever seen a moth flutter to a candle, and singe his wings? A ship will do the same to a false light."

Wreckers or Mooncussers—so named because they cursed the light of the moon when it interrupted their attempts to lure merchant ships aground—salvaged the goods that washed ashore. Even though wrecking was a crime punishable by hanging, they considered their work a "condonable offence" because it was their only means to supplement their meager incomes.

How much of England's—and the world's—sea glass and shards is the result of the work of mooncussers?

This pottery shard, part of a Dundee marmalade crock, was found in Cornwall, England. It measures 1¾" x 1½".

This shard, found in Donegal, Ireland, measures 1¼" x 1".

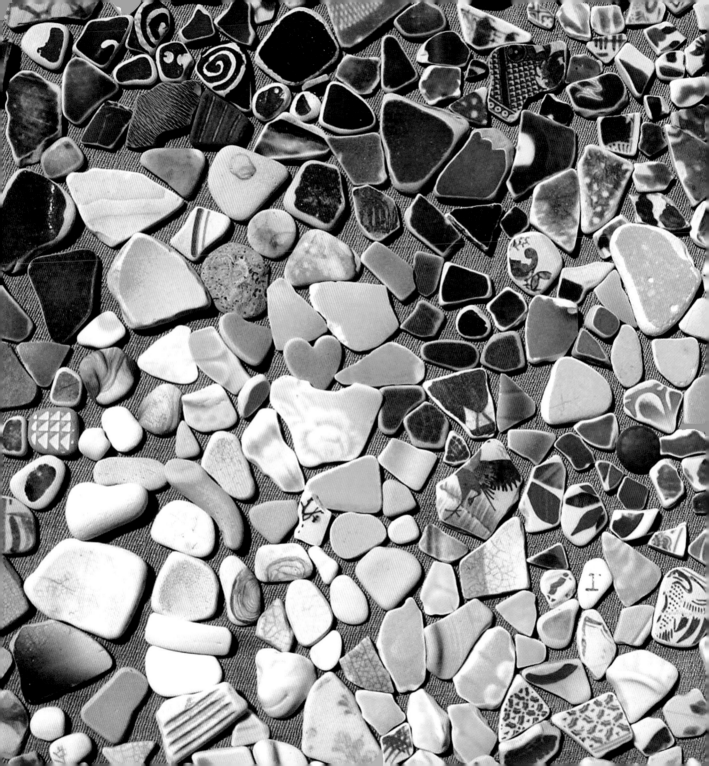

Acknowledgments

Thank you to the following friends and family for their support and encouragement: Alex Barnes, Joanna Beyer, Karen Cadbury, Meg Carter, Pauline Carver, Matthew and Regina Chan, Martin and Dora Cheung, Kwan and Debbie Chung, Christie Cummins, Kirsti and Jonathan Hoover, Anthony Hutcheson, Linda Jereb, Steven Jones, Hing Bing and Anne Lau, Anthony, Dawn, and Grace Lau, Laura Meade, Angela Mondelli, Vivian Morosi, the North American Sea Glass Association, Diana Nuhn, Basil Panourgias, Joan and Tom Sabatino, Sea Glass Lovers, Tammy Smith, Susan Stackpole, Michael Steere, Louis and Angela Tong, Ellen Urban, Kaja Veilleux, Sandy Whitney, and Kathy Zvanovec.

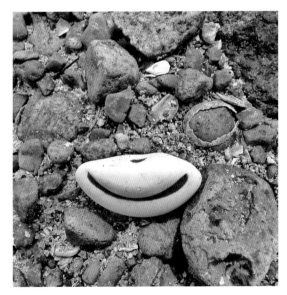

Sea glass makes us happy. This pottery shard, found in Yorkshire, England, measures 2¼" x 1½".

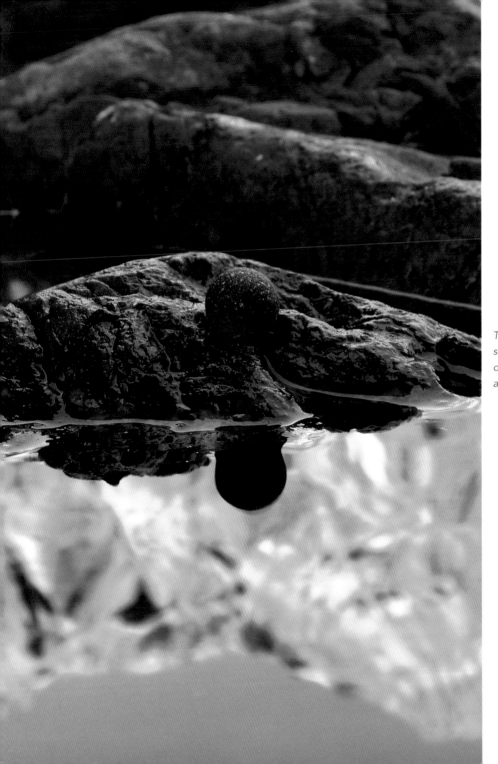

This marble may have come from a seaside arcade or perhaps it's a remnant of a childhood game played decades ago.